CREATING TEXTURES in PEN & INK
with WATERCOLOR

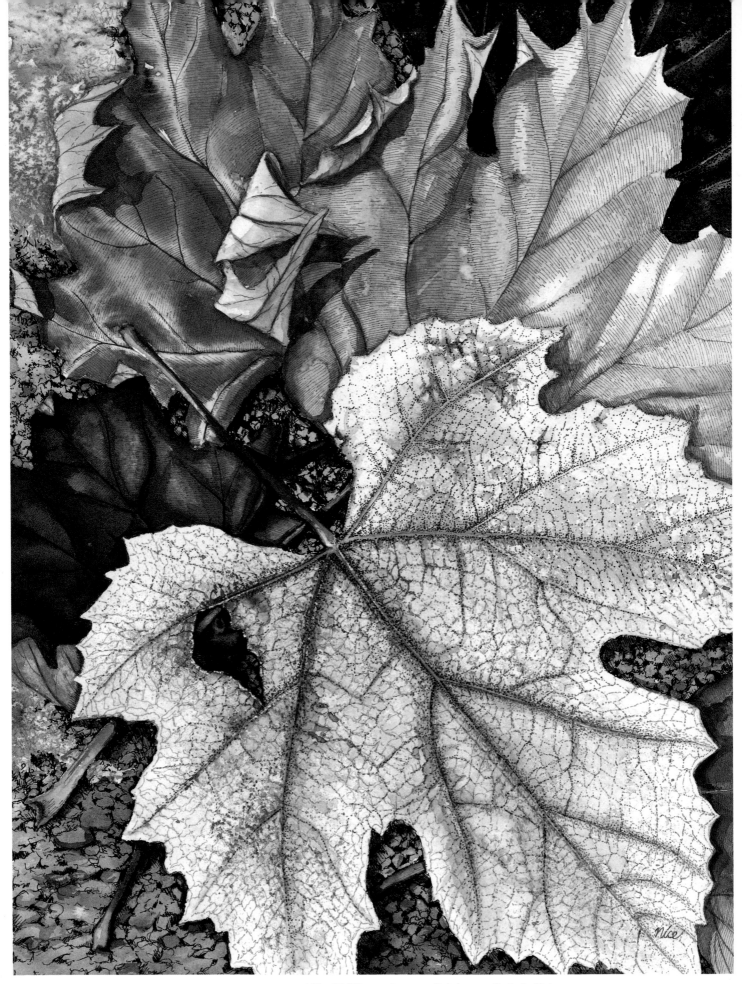

AUTUMN TEXTURE, 10″×7″, Watercolor, pen & ink, pen & ArtistColor.

CREATING TEXTURES

IN

PEN & INK

WITH

WATERCOLOR

CLAUDIA
NICE

NORTH LIGHT BOOKS
www.artistsnetwork.com

ABOUT THE AUTHOR

Claudia Nice was born in Shelton, Washington, and spent her childhood years in Portland, Oregon. It was the call of the nearby Cascade mountain range and her family's numerous camping trips that developed her love of nature.

Claudia began experimenting with art materials at a young age, sketching anything that would hold still. She gained basic art skills and encouragement from grade school and high school art classes. She won a scholarship for summer art classes at the University of Kansas, where she began sketching in pen and ink.

Claudia and her husband Jim presently reside in the scenic Columbia River Gorge on the Oregon border. She travels as an art consultant for Koh-I-Noor Rapidograph and Grumbacher, teaching workshops across the nation and Canada. She has authored ten books, numerous magazine articles and has exhibited her work extensively.

Creating Textures in Pen & Ink with Watercolor. Copyright © 1995 by Claudia Nice. Manufactured in China. All rights reserved. No part of this book may be reproduced in any form or by any electronic or mechanical means including information storage and retrieval systems without permission in writing from the publisher, except by a reviewer, who may quote brief passages in a review. Published by North Light Books, an imprint of F+W Publications, Inc., 4700 East Galbraith Road, Cincinnati, Ohio, 45236. (800) 289-0963. First paperback edition 2005.

Other fine North Light Books are available at your local bookstore, art supply store or direct from the publisher.

15 14 13 12 11 9 8 7 6 5

Library of Congress has cataloged hardcover edition as follows:

Nice, Claudia
 Creating textures in pen & ink with watercolor / by Claudia Nice.
 p. cm.
 Includes index.
 ISBN-13: 978-0-89134-595-4 (hardcover)
 ISBN-10: 0-89134-595-7 (hardcover)

 ISBN-13: 978-1-58180-725-7 (pbk.: alk. paper)
 ISBN-10: 1-58180-725-2 (pbk.: alk. paper)
 1. Pen drawing—Technique. 2. Watercolor painting—Technique.
 3. Texture (Art)—Technique. I. Title.
NC905.N52 1995
751.4'2—dc20 95-12916
 CIP

Edited by Rachel Wolf and Kathy Kipp
Designed by Sandy Conopeotis Kent
Cover illustration by Claudia Nice

fw
F+W PUBLICATIONS, INC.

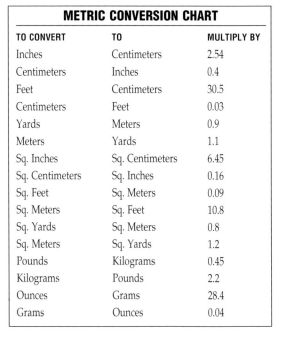

METRIC CONVERSION CHART		
TO CONVERT	TO	MULTIPLY BY
Inches	Centimeters	2.54
Centimeters	Inches	0.4
Feet	Centimeters	30.5
Centimeters	Feet	0.03
Yards	Meters	0.9
Meters	Yards	1.1
Sq. Inches	Sq. Centimeters	6.45
Sq. Centimeters	Sq. Inches	0.16
Sq. Feet	Sq. Meters	0.09
Sq. Meters	Sq. Feet	10.8
Sq. Yards	Sq. Meters	0.8
Sq. Meters	Sq. Yards	1.2
Pounds	Kilograms	0.45
Kilograms	Pounds	2.2
Ounces	Grams	28.4
Grams	Ounces	0.04

I dedicate this book with love to my parents. To my father who passed to me his creativity, and taught me to love nature from the business end of a fishing pole.

To my mother who read to me and instilled in my mind the love of good books, and a colorful imagination with which to create my own.

Above all, I dedicate this book to my creator who answered many prayers and made all things possible.

Thank you, Jim, for your patience, encouragement and support.

INTRODUCTION

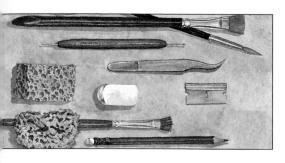

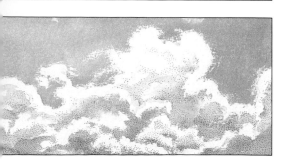

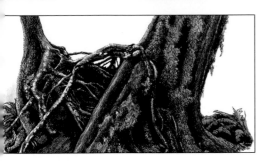

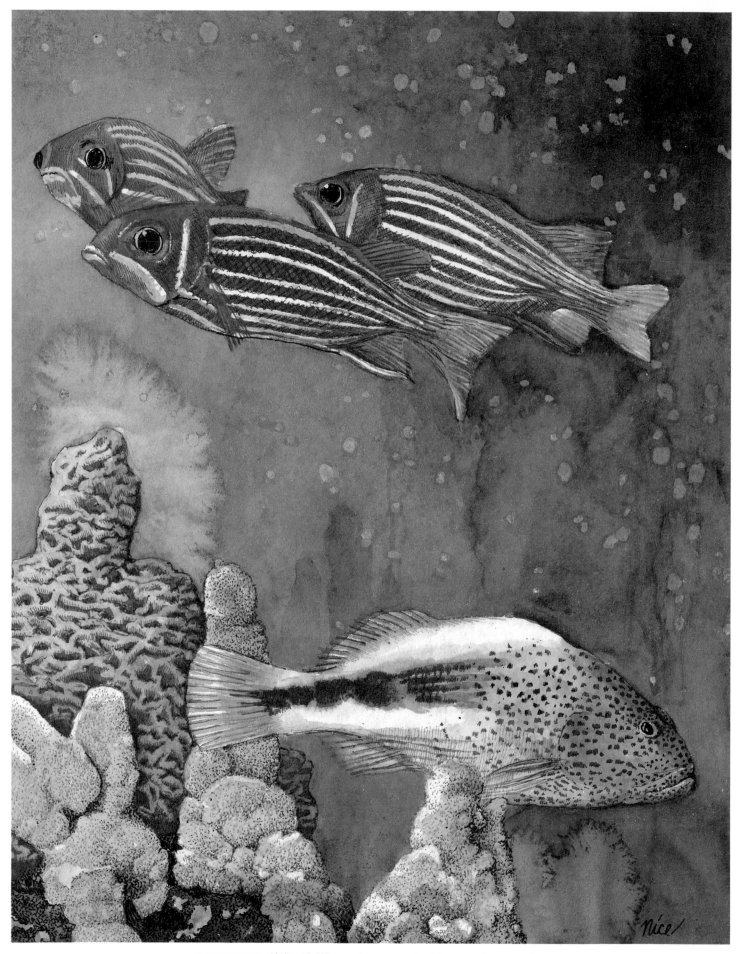

REEF FISH, 9½″ × 7″, Watercolor textured with colored pen work.

INTRODUCTION

I first learned to appreciate texture as a pen-and-ink artist. Value contrasts and texture are the heart of an ink drawing. I discovered that stippled dots could become gritty sand or a velvety horse muzzle. Thick tangled foliage, flowing water, soft rabbit fur, weathered wood and the leathery folds of elephant skin could all be depicted with the stroke of a pen. I was hooked, but I missed the colorful vibrance of paint. A dew-dappled flower petal or the misty arch of a rainbow needed color to be at its glorious best. The solution was to combine the best of both mediums. The result: some really fun and exciting mixed media techniques. A lot of them were old standards. Salt techniques have been around almost as long as watercolor. However, it took a lucky accident to reveal to me what happens when rock salt falls into water and bounces into a wet wash—a lacy sea anemone is born. Ink stippling over a bump-shaped, washed area becomes coral with personality. A bit of alcohol spatter tucked between layers of sea-green watercolor brings an otherwise dull background to life. I now have a colorful reef scene with texture, as you can see on the facing page!

The knowledge of many watercolorists, months of experimentation, and dozens of accidents, both good and bad, have combined to become the techniques I share with you in this book. I have only touched the surface. There are vast combinations of mixed media textures waiting to be tried and appreciated. Armed with a pen, brush and the spirit of adventure, the next "textural discovery" could be yours.

Happy Texturing.

Claudia Nice

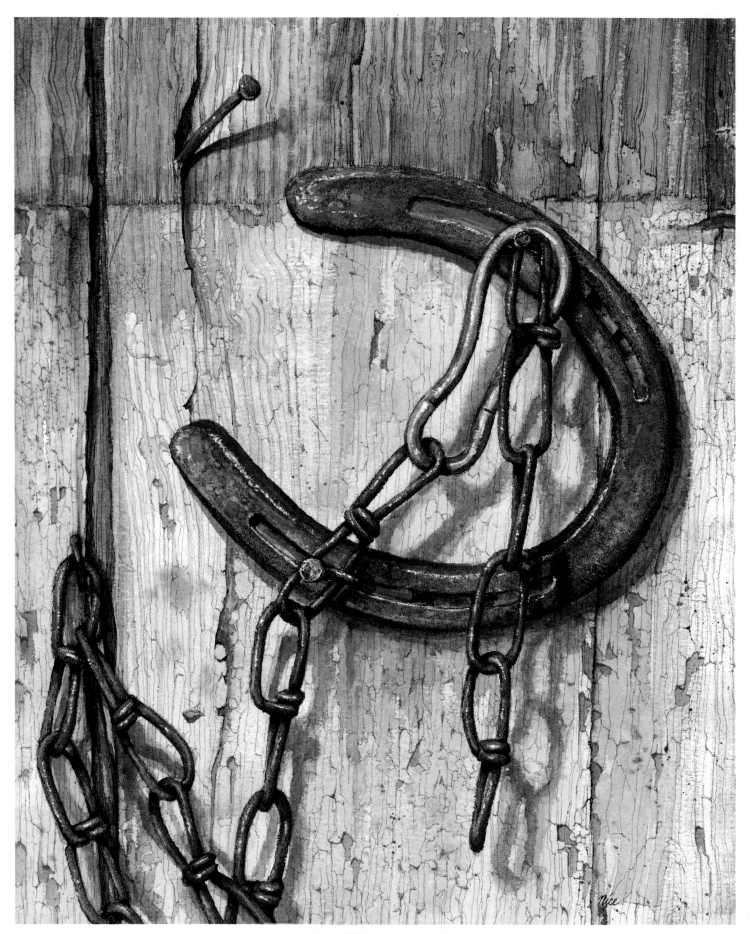

GATHERING RUST, 9¾″ × 7¾″, Watercolor, pen & ink, pen & ArtistColor.

MATERIALS

THE TECHNICAL PEN

The technical pen is an advanced drawing instrument consisting of a hollow nib, a self-contained ink supply and a plastic holder. Within the hollow nib is a delicate wire (which should not be removed from the nib); and a weight, which shifts back and forth during use, brings the ink supply forward. An ideal pen has a steady, leakfree flow and a precise nib that can be stroked in all directions.

With proper use and maintenance, the technical pen is the answer to the "perfect art pen." I find I am most comfortable using a Koh-I-Noor Rapidograph. It is dependable and the refillable cartridge allows me to choose my own ink or colored medium.

Technical pens come in various nib sizes, ranging from very fine to extra broad. The line width chart at right shows both the Rapidograph nib sizes and their equivalent metric line widths. For a first pen, I recommend nib size 3×0/.25mm. Most of the detail work shown in the illustrations in this book were created using a 3×0 sized pen. I have indicated the sizes of the Rapidograph pens I used on many of the projects by placing the numbers in parentheses beside the sketches.

PEN USE AND MAINTENANCE

Hold the pen as you would a pencil, keeping the angle rather upright. Use a steady, light pressure, maintaining good contact with the drawing surface.

Do not shake the technical pen! Shaking tends to flood the air channel with ink, creating a vacuum that prevents ink flow. If ink flow stops suddenly, try tapping the end of the pen holder (nib pointing skyward) against the table.

Keep the pen cap on when not in use. Wipe the nib often using a lint-free cloth when working over watercolor paint. Clean the pen thoroughly, following the manufacturer's instructions, at least once a month, or when changing inks or colored mediums.

For a more complete reference on using the Rapidograph pen—maintenance, textural stroking, and various styles and techniques—refer to *Sketching Your Favorite Subjects in Pen & Ink*, by Claudia Nice (North Light Books, 1993).

THE CROW QUILL

The crow quill dip pen consists of a wooden or plastic holder and a removable steel nib. With Hunt nibs no. 102 (medium) and no. 104 (fine), the crow quill will provide a good ink line. The tool cleans up easily and is inexpensive. It's useful for applying colored mediums when you desire many color changes or wish to add a finishing touch without filling a Rapidograph. Final touches of liquid acrylic were applied to *Gathering Rust* (page 2) and *Along the Trail* (page 72). However, crow quills are limited in stroke direction, with a tendency to drip and splatter, and the redipping process interrupts the stroking rhythm.

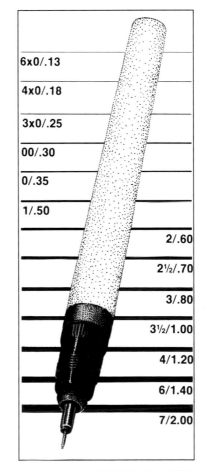

Nib size / mm
6x0/.13
4x0/.18
3x0/.25
00/.30
0/.35
1/.50
2/.60
2½/.70
3/.80
3½/1.00
4/1.20
6/1.40
7/2.00

TECHNICAL PEN

INK

India Inks are composed of water, carbon black particles for rich, dark color and shellac or latex for a binder. Different blends of these ingredients determine the ink's opacity, surface drying time, adhesion and permanence. India Ink labeled "permanent" should hold up under high humidity situations, adhering well to the drawing surface when touched with a damp finger. However, even "waterproof" inks may smear or lose pigment when brushed over with washes of watercolor, diluted ink or acrylic. Test the ink on scratch paper before applying any type of wash to your sketch.

My favorite ink is Koh-I-Noor's Universal Black India (3080), a versatile, high-opacity black ink that is free flowing, fast drying, and withstands vigorous brushing with colored washes.

COLORED INKS

Dye-based colored inks flow nicely in the technical pen, but some have a tendency to fade over a period of time. Many are not permanent, let alone brushproof. Check the labels for lightfast ratings, and run your own test for permanence before using it as part of a mixed media art piece.

Note: The ArtistColor liquid acrylics mentioned alongside some of the illustrations in this book is no longer available. I am presently using Koh-I-Noor Drawing Ink 9065, for all of my colored ink work. This too is subject to change according to product availability.

WATERCOLOR

The watercolor techniques discussed in this book require a quality watercolor paint in order to work effectively. Look for a watercolor paint that has rich, intense color for a good tinting strength. It should be finely ground and well processed so that the washes appear clean, with no particulate residue. The majority of the mixed media art pieces in this book were created using Grumbacher Finest Watercolor. Whatever your brand choice, remember that it is better to have a limited palette of quality paints than a kaleidoscope of poor substitutes. Your choice of paints will be reflected in your work.

THE COLOR WHEEL

The color wheel chart shows a simple palette of six basic colors: Cadmium Yellow Medium (warm yellow), Cadmium Yellow Lemon (cool yellow), Ultramarine Blue (warm blue), Thalo Blue (cool blue), Cadmium Red Light (warm red), and Thio Violet or Quinacridone Red (cool red). From these six colors, the three primary colors (yellow, red and blue) can be mixed (a theory that goes against Art Class 101, but works great!). The usual basic mixing palette of pure red, blue and yellow is valid, but each primary color must be "hue perfect" (almost impossible to find in manufactured color) in order to produce vibrant secondary mixtures.

Using a basic palette of six warm and cool "primary" colors will produce a full spectrum of intense, accurate secondary and intermediate colors (greens, browns and or-

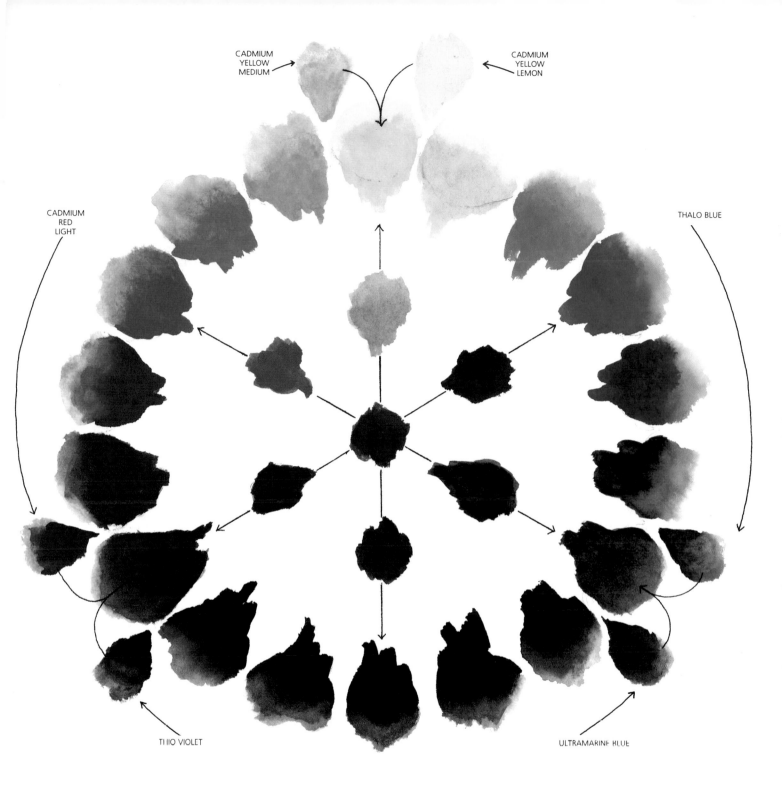

THE COLOR WHEEL

A simple palette of six basic warm and cool colors can produce a full spectrum of vibrant mixed hues, as well as earthy tones and rich shadow colors. Warm and cool grays can be mixed from Cadmium Red Light, Thio Violet, Ultramarine Blue and Thalo Blue. Neutrals (in the center of the chart) can be mixed from varying amounts of complementary colors, such as yellow and purple, green and red, or orange and blue.

LIQUID ACRYLICS

For colored pen work, I prefer using Rotring's ArtistColor (transparent), referred to in this book as *liquid acrylic*. It is a finely pigmented, transparent, permanent acrylic that is made especially for air brushes and technical pens as well as brush application. It is quick drying and, once dry, completely brushproof. Being transparent, it is very compatible with the "watercolor look," and works well layered over or under watercolor washes. At my work station, I keep a 3 × 0 pen filled with ArtistColor Payne's Gray for shading cool watercolor washes, and a pen filled with ArtistColor Brown to accent warm colors. Unless one has an abundance of technical pens, other liquid acrylic hues can be mixed and placed in the pen as needed.

Caution: White and Black ArtistColor have a heavier pigment concentration and are not recommended for the medium- and fine-nibbed Rapidographs. The other transparent colors are treated like inks and should be maintained in the pen as such.

BRUSHES

The best brushes to use with watercolors are sable hair. Soft, absorbent sable brushes are capable of holding large amounts of fluid color, yet retain a sharp point or edge. They respond to the hand with a resilient snap. The big drawback is that sable is expensive. An alternative choice is a quality blend of natural and synthetic sable hairs. The illustrations in this book were painted using both sable and blended brushes (Grumbacher Sables and Sable Essence in various sized flats, rounds and fan shapes.) Also useful is an old, frayed, synthetic flat brush for stippling, scrubbing and general misuse.

WATERCOLOR PAPER

When working in mixed media you must choose a surface that is compatible with both pen work and the application of wet washes. The pen should be able to glide over its surface without snagging, picking up lint, or clogging. The paper must be absorbent enough to avoid buckling into molehills when wet-on-wet techniques are used. To ensure the longevity of your work, the paper should have a high rag content and be pH neutral.

A good quality, cold-pressed watercolor paper of 125- to 140-lbs. seems to be a good compromise. Taping the edges of the paper to a moveable backing such as a drawing board will help the surface retain its shape, but still allow the paper to be rotated for pen work.

MISCELLANEOUS

Liquid frisket is used to mask out areas of a painting while washes are applied. Use a synthetic-hair brush for application, dipped first in liquid soap to aid in cleanup. Remove the liquid frisket from the work surface with an eraser.

Table salt and rock salt are used for the salt techniques in this book. Don't be afraid to experiment with sea salt, marguerita salt, kosher salt, etc. Rock salt needs to be dipped into water as it's applied, to cause the saline solution to flow. In high humidity areas, microwave the salt to dry it, and keep it in a sealed container.

Isopropyl rubbing alcohol, plastic wrap, spray mist bottles, paper towels and paper tissues are all handy items to have on hand. They can be used to alter the pigment flow, creating spontaneous, fun, textured effects. You can see how to create many of these effects on pages 14-21.

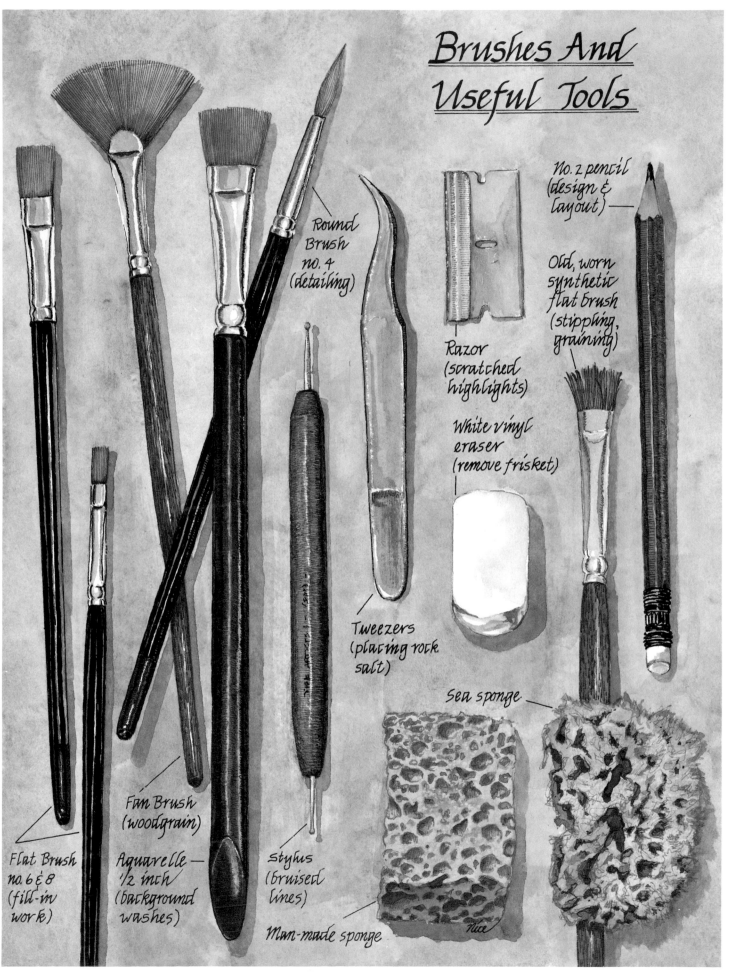

Brushes And Useful Tools

Round Brush no. 4 (detailing)

No. 2 pencil (design & layout)

Old, worn synthetic flat brush (stippling, graining)

Razor (scratched highlights)

White vinyl eraser (remove frisket)

Tweezers (placing rock salt)

Flat Brush no. 6 & 8 (fill-in work)

Fan Brush (woodgrain)

Aquarelle — ½ inch (background washes)

Stylus (bruised lines)

Man-made sponge

Sea sponge

Nice

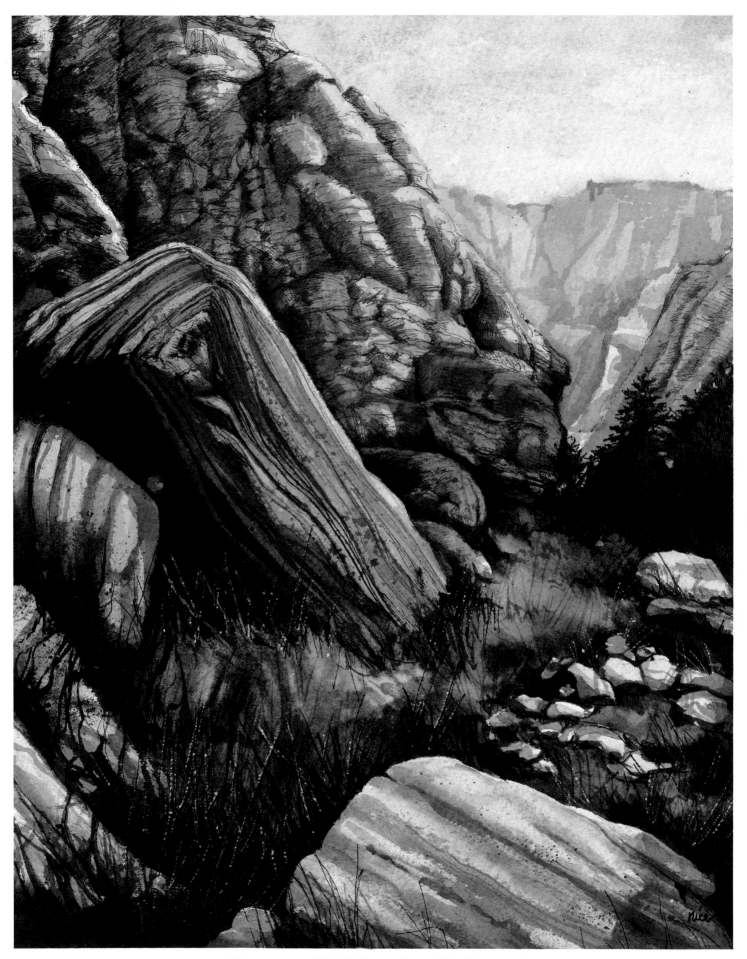

CANYON WALLS, 9½″×7″, Pen work overlaid with watercolor.

BASIC TEXTURING TECHNIQUES

Pen and ink is my favorite texturing medium. Dots and lines can be varied in size, volume, arrangement and form to create the appearance of texture. There are seven distinct texturing techniques: contour lines, parallel lines, crosshatching, dots or stippling, scribble lines, wavy grain lines and crisscross lines. Each technique may be used separately or combined to produce countless effects. When the texture of pen work is desired, but India Ink lines are too prominent, earth tone mixtures of liquid acrylic may be substituted in the pen.

Watercolor is subtle in its display of texture. However, the softer look of brush-produced strokes and "water flow" textures are greatly enhanced by the impact of color. Dynamic choice of hue can "wake up" a tenuous texture to produce striking realism. Watercolor texturing depends greatly on the reactions of pigmented washes to dry, damp, and wet paper surfaces. The wetter the surface, the softer and more free flowing the applied paint will become. The use of various brushes and tools to apply (or remove) the paint is equally important to the creation of textural effects. Application techniques include stroking, scraping, spattering, stamping and blotting. Salt, liquid frisket, alcohol, plastic wrap and plain water can be used to alter the distribution of the pigment, producing even more visual variants.

By combining the boldness of pen and ink, the subtle qualities of watercolor and the visual impact of color, the creation of texture is only as limited as your imagination.

Pen And Ink Techniques

Contour Lines –

(smoothly flowing, form fitting strokes)

- smooth, curved objects
- polished surfaces
- fluid motion
- glass, metal

The seven basic texturing strokes can be layered or combined to produce countless effects.

Crosshatching –

(two or more intersecting lines)

- deepen tonal values, heavy shadows
- roughened texture varying in degrees according to angle, precision and nib size

Parallel Lines –

(straight, free hand lines, stroked in the same direction)

- smooth, flat objects
- faded, hazy, misty or distant look

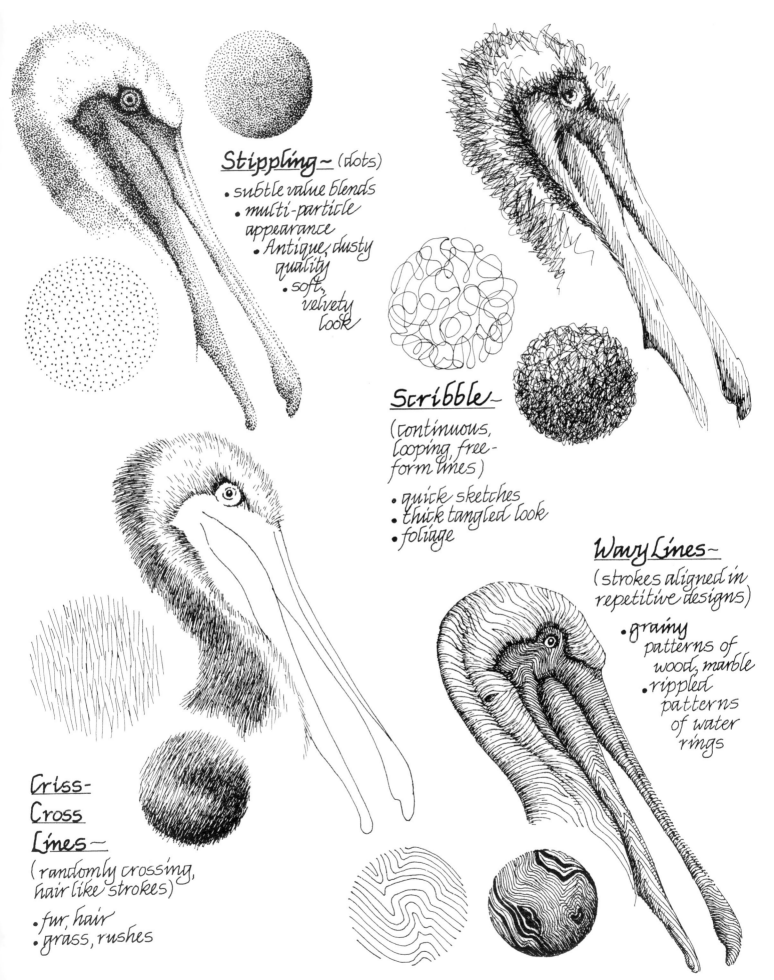

Stippling ~ (dots)

- subtle value blends
- multi-particle appearance
- Antique, dusty quality
- soft, velvety look

Scribble ~

(continuous, looping, free-form lines)

- quick sketches
- thick tangled look
- foliage

Wavy Lines ~

(strokes aligned in repetitive designs)

- grainy patterns of wood, marble
- rippled patterns of water rings

Criss-Cross Lines ~

(randomly crossing, hair like strokes)

- fur, hair
- grass, rushes

Value is the degree of lightness or darkness in a color. India Ink work has a palette ranging from white, through the various gray tones to black. The more marks added to the paper surface, the greater the degree of darkness.

Value deepened by stroking lines closer together

Value deepened by layering sets of pen strokes

Value deepened by combining different texture layers

Subtle blending of values

Stippling provides the most delicate means of blending value using pen and ink techniques.

Placing dark objects against lighter backgrounds and vice versa provides a natural edge where the two values meet. The greater the contrast between the two values, the more distinct the form of the object will become.

Contrast is the key to a well-defined art piece.

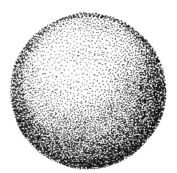

Below: Shapes defined by contrast of value.

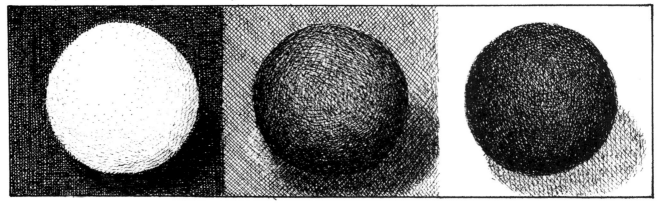

Techniques for developing contrast and definition ~

Pen and ink

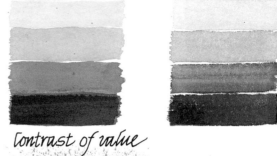

Contrast of value

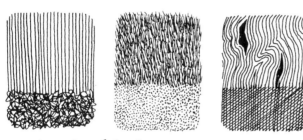

Contrast of texture

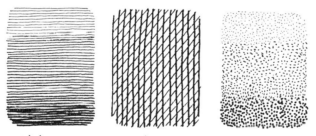

Line - direction variation

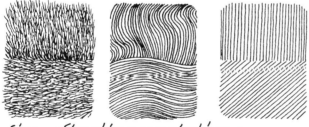

Nib size variation

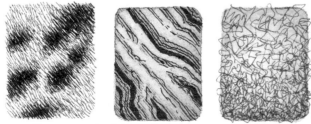

Color variation

Brush and watercolor

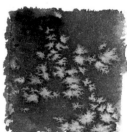

Contrast of value

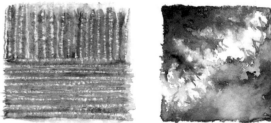

Contrast of texture

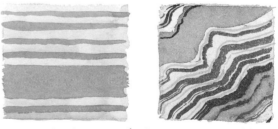

Stroke direction variation

Brush size and shape variation

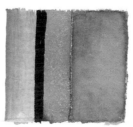

Color variation

Dry Surface Techniques

Drybrushing - (moist paint applied to a dry surface) produces crisp-edged lines and paper induced textures as the brush dries out.

Round detail brush stroked over dry paper.

Round detail brush stroked over a dry wash.

Flat brushes stroked over dry paper surface.

As moisture leaves flat brush, paper texturing occurs.

Flat brush stroked over dry wash.

Edge of flat brush stippled over dry, mottled wash.

Fan brush stroked over a dry wash.

Lines scratched into a dry wash with a razor blade.

Round and flat brush strokes on a damp paper surface.

Varied washes on a damp surface. Note smooth blending of hues.

Damp Surface Techniques

Pigment spreads easily when stroked over a moist (not shiny) surface, producing softened edges and smooth blends.

Stroking the edge of a damp wash with a clean, moist brush produces a gradated blend.

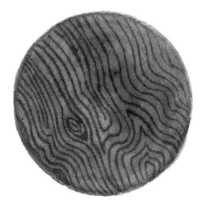

Bruising the paper with a stylus causes the pigment in a damp surface wash to gather into dark lines.

Scraping through a near-dry wash with a blunt tool creates lightly pigmented designs.

White area protected from damp surface wash with masking tape.

White design area masked with liquid frisket.

Liquid frisket applied over a dry wash, followed with a darker, damp surface wash.

Wet-On-Wet Techniques

Moist paint applied to a shiny wet surface will flow freely, creating soft, feathery designs.

Spontaneous design resulting from wet-on-wet application.

Flat and round brushes stroked over a wet surface.

Spontaneous mixture of varied hues applied to a wet surface.

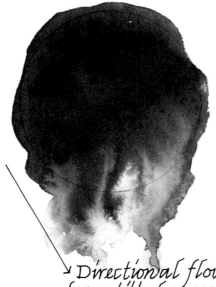

Directional flow from tilted paper.

Pigment-filled round brush touched to wet surface.

Edge of wet-on-wet wash sprayed with spray mister.

Puddling occurs when additional liquid is applied to a wet-on-wet wash.

A water-filled round brush touched to a wet, varied wash.

Pigment lifted from
a moist wash with
a damp, flat brush.

A near-dry wash,
worked with a damp,
flat brush and lifted
with a tissue.

Absorbent materials
pressed into a damp-
to-wet wash will lift
the pigment, creating
negative designs.

Moist washes blotted with a crumpled paper tissue.

Damp surface wash,
blotted with a
paper towel.

Varied, wet-on-wet
wash, blotted with
a paper towel.

Dry, multi-layered
wash, worked with
a damp brush and
lifted with a tissue.

Impressed Textures

Foreign materials laid into a moist wash and left to dry completely, will draw and hold the pigment, creating dark print-like designs.

Crumpled wax paper - weighted down.

Crumpled plastic wrap - weighted down with a book.

Crumpled tin foil

Sewing thread

Fine hairs from a Chow dog's inner coat. (Pat into place with a brush.)

Spring leaves

Tooth picks

Coarse sand

Horse tail hairs

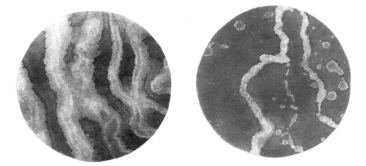

Salt And Alcohol Techniques

Introducing rubbing alcohol or salt into a very damp to wet wash will displace the pigment, creating pale designs.

Rubbing alcohol applied with the tip of a round detail brush.

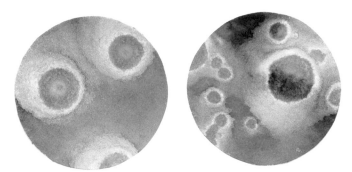
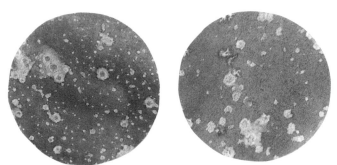

Large drops of alcohol, dripped into a moist wash from the tip of a brush.

Fine drops of alcohol, spattered into a moist wash.

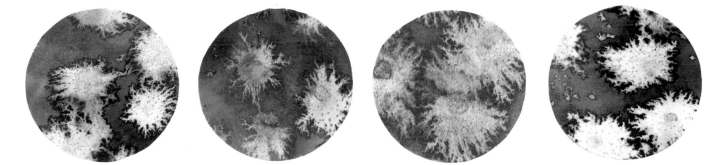

Wet pieces of rock salt, laid into a moist wash and left until dry.

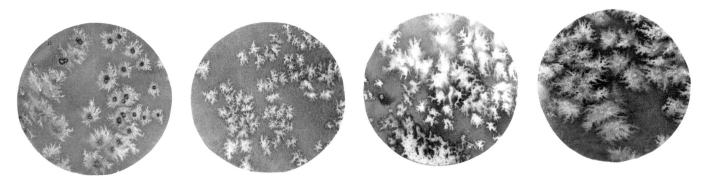

Table salt sprinked into a moist wash and left until dry.

Under humid conditions, salt must be dried in an oven or microwave before use.

Spatter

When paint is flicked, flung or sprinkled onto the paper, random spatter patterns are formed that have a dusty, crumbly, gritty or pebbly texture.

Directional spatter has the look of exploding motion.

Directional spatter - flicked off a finger tip with a flat, stiff brush.

Wet on wet spatter

Layered spatter over dry surface

Blotted spatter

Paint flung from brush

Drops of sprinkled wash over fine spatter

Wet wash sprayed with clear water

Water drop marks on damp and wet surface

Liquid frisket spattered beneath a light wash

Sea sponge wiped
across paper
surface

Printed on dry
paper with a
pigment filled
sea sponge

Layers
of sea
sponge
printed
over a
damp wash.

Printed with a
damp man-made
sponge which has
been brushed with
varied colors.

As the sponge loses
moisture the de-
sign becomes more
distinct.

Stamping
Stamping is the process
of imprinting a texture
or design on paper.

Nature prints — fresh
leaves were brushed with
pigment and pressed to
a dry paper surface

21

Combining Pen, Ink And Watercolor

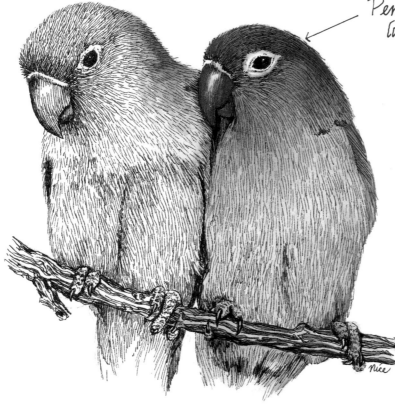

Pen and India Ink drawing over-laid with watercolor washes

- Main emphasis is on pen and ink work
- It has a bold, highly textured appearance

Watercolor painting overlaid with pen and ink texturing

- Main emphasis is on watercolor brushwork
- Tends to be more spontaneous and delicate when brushwork is done before pen work

The addition of India Ink marks lends texture and substance to the clouds, rocks and waves.

Preliminary wash
brushed on damp
surface (let dry)

Paint mixture
is darkened and
second layer added

ArtistColor mix
is placed in pen
(3x0) and detail
lines stroked on

Shadows
are brushed
on

Layers of liquid acrylic applied
by both brush and Rapidograph pen

- Allows subtle blend of color and texture
- Can have very detailed, photo realistic quality
- Dries waterproof

Intermixed layers of India Ink,
liquid acrylic and watercolor,
utilizing various techniques
and applications

- Unlimited variety
 of color, textures
 and techniques
- Opacity can
 vary

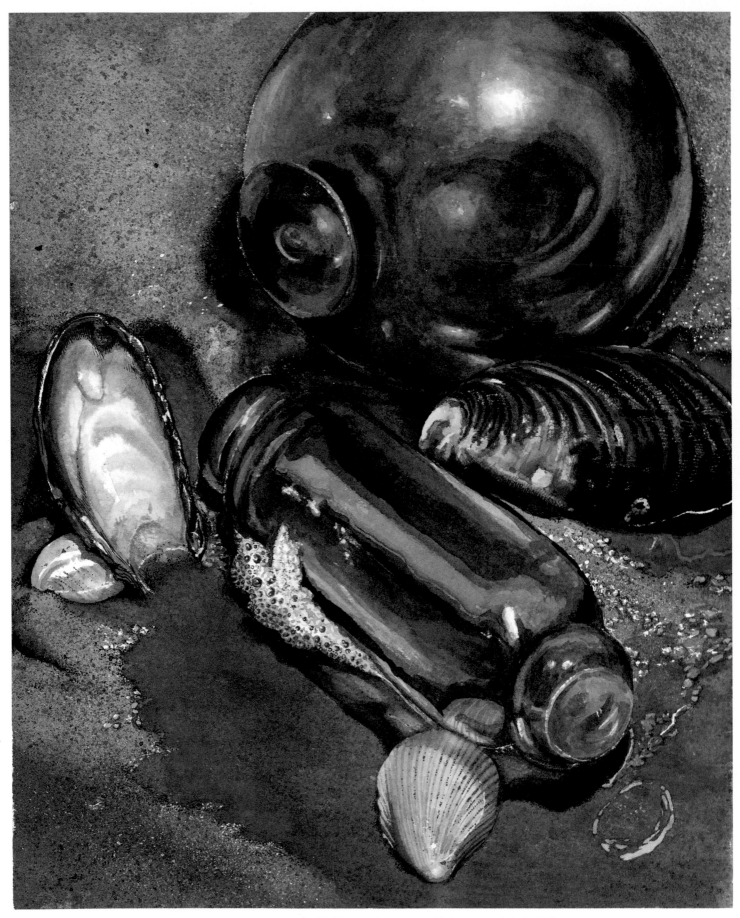

WASHED ASHORE, 10″×8″, Watercolor, pen and ink, pen and ArtistColor.

THE LOOK OF TRANSPARENCY

Transparency, because of its elusive, delicate nature, can be a challenge to depict. Indeed, the surface of a clear, pristine pool of water or a newly washed window can be almost invisible to the eye if it were not for the glint of reflected light. It's perhaps easiest to consider a transparent object in three aspects—the surface, the inside and the back side.

While the surface contours of untinted transparent objects are often evasive, the highlights and reflective colors are quite visible. Concentrate on this "light play" and the surface contours will be depicted in a natural manner.

The inside of the transparent object is the next area of consideration. Interior shadows will help define the inner shape. Objects within the transparent subject will add interest, but keep in mind that their shape and texture may appear distorted. Colors within a transparent object, especially liquids, are intensified and, depending on the whims of illumination, may appear darker or lighter than the surrounding outside area.

Last of all, the back side is considered, and more important, any background objects seen through the transparent surfaces. The farther away they are, the more faint and distorted they will appear.

Although transparent objects can be depicted adequately in pen and ink using contour lines, watercolor lends itself especially well to this work. Therefore, I often begin with a watercolor painting and carefully add touches of pen and ink, or the more subtle tones of liquid acrylic, to deepen shadows and enhance definition.

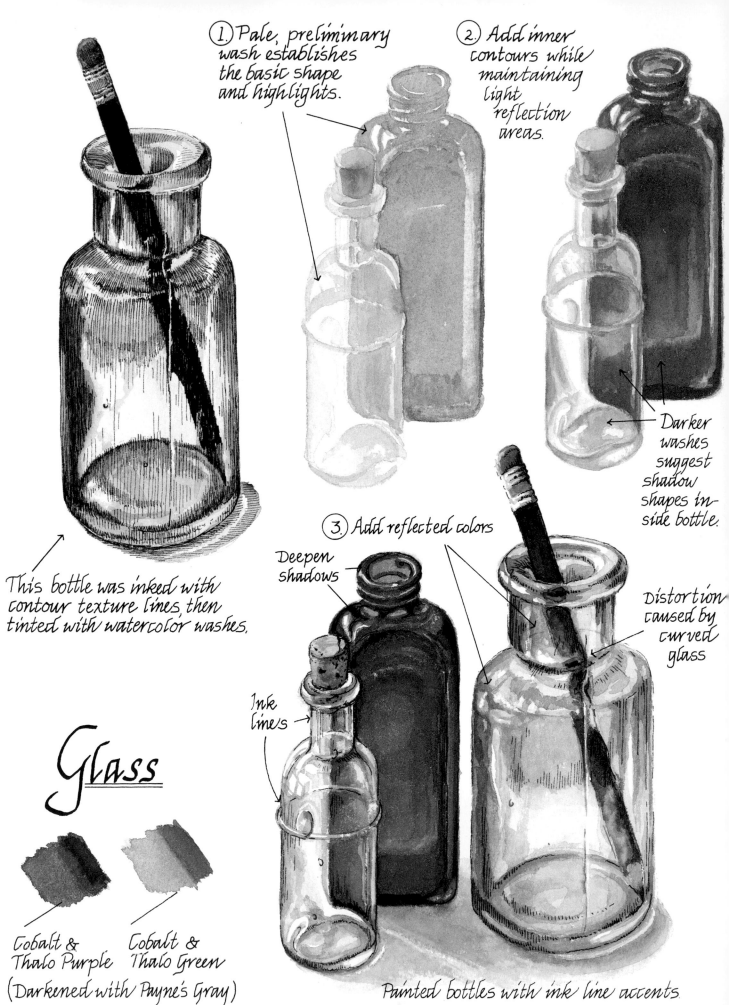

1. Pale, preliminary wash establishes the basic shape and highlights.

2. Add inner contours while maintaining light reflection areas.

Darker washes suggest shadow shapes inside bottle.

This bottle was inked with contour texture lines, then tinted with watercolor washes.

3. Add reflected colors

Deepen shadows

Ink lines

Distortion caused by curved glass

Glass

Cobalt & Thalo Purple

Cobalt & Thalo Green

(Darkened with Payne's Gray)

Painted bottles with ink line accents.

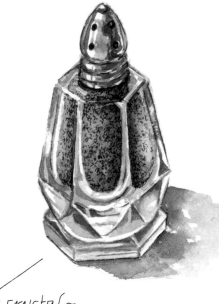

Contour ink lines for definition

liquid frisket was used to protect white highlights during paint application.

highlights reflected from flame

Objects behind glass often appear distorted

stippled ink texturing

reflected color

amber colored lamp oil

Lighter colors represent the illumination of light filtering through the lamp.

Cut crystal~
 Faceted surfaces reflect multiple highlights, shadows and reflected color. Simplify this "light play" where possible and maintain plenty of sparkling white highlights.

(The pepper in the shaker was textured with ink scribble marks and dots.)

As clear, antique glass ages it often takes on an amethyst tint.

This antique lamp was painted with layers of watercolor washes, then a few well placed ink texturing strokes were added.

Rose Madder & Payne's Gray

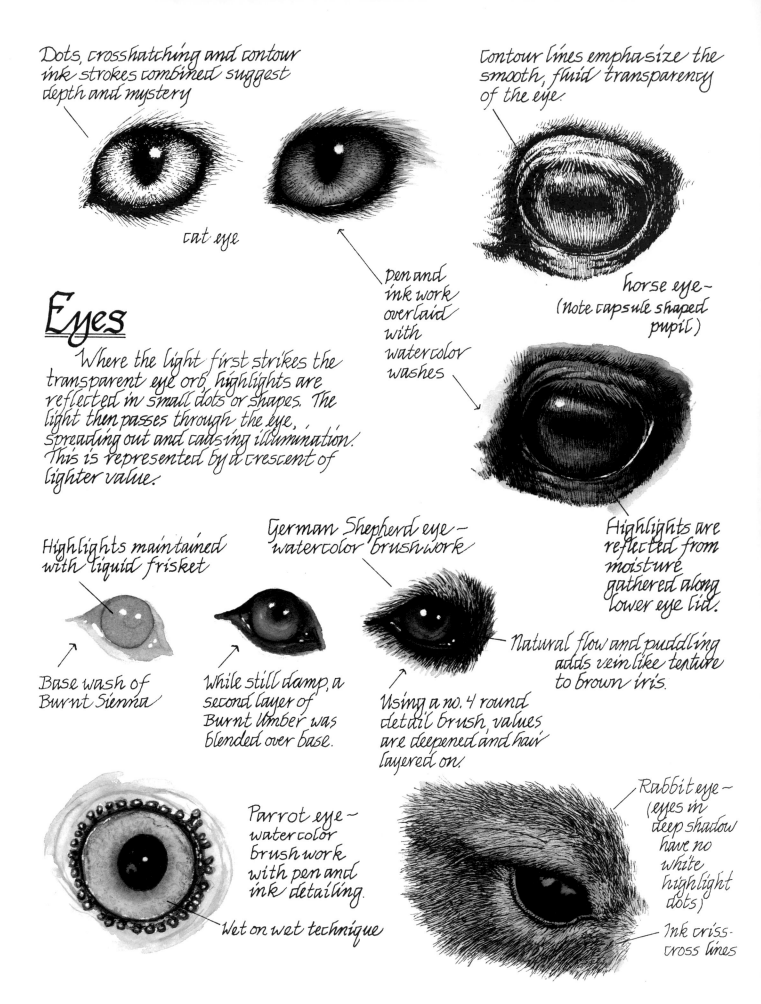

Dots, crosshatching and contour ink strokes combined suggest depth and mystery

cat eye

Contour lines emphasize the smooth, fluid transparency of the eye.

Pen and ink work overlaid with watercolor washes

horse eye — (Note capsule shaped pupil)

Eyes

Where the light first strikes the transparent eye orb, highlights are reflected in small dots or shapes. The light then passes through the eye, spreading out and causing illumination. This is represented by a crescent of lighter value.

Highlights are reflected from moisture gathered along lower eye lid.

German Shepherd eye — watercolor brush work

Highlights maintained with liquid frisket

Base wash of Burnt Sienna

While still damp, a second layer of Burnt Umber was blended over base.

Using a no. 4 round detail brush, values are deepened and hair layered on.

Natural flow and puddling adds vein like texture to brown iris.

Parrot eye — watercolor brush work with pen and ink detailing.

Wet on wet technique

Rabbit eye — (eyes in deep shadow have no white highlight dots)

Ink criss-cross lines

Pen and India ink
(3x0)

Pen and ink over laid with watercolor washes

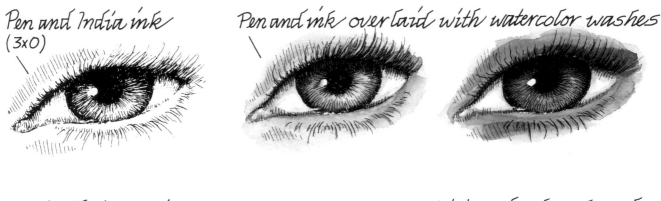

Basic flesh tone is a mixture of Brown Madder, Burnt Sienna and Thalo Green watercolor.

Deepen skin color by adding Thalo Green and Thio Violet.

Add texture with similar mixes of liquid acrylic in a 3x0 pen.

Watercolor brush work, over laid with pen and India ink, and pen and liquid acrylic texture strokes.

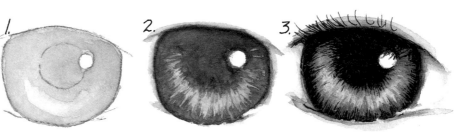

1. 2. 3.

① Lay a basic wash over a light pencil sketch, maintaining high lights

② While still slightly damp, shade and deepen value, leaving an illumination crescent

③ Add pen and ink accent strokes

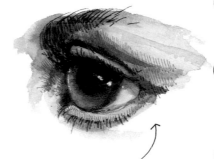

Watercolor, textured with pen work

31

Preliminary watercolor washes-damp surface and wet on wet techniques

Maintain the white spray areas by masking with liquid frisket

Warm hues suggest rocks beneath the surface, adding to the look of transparency

The under washes establish the direction of water flow, as well as shapes and shadows.

Whitewater

Contour ink detail lines are added, further suggesting the direction of water flow.

The water behind the rocks is darkened with damp and dry-brush work.

Scraped lines add sparkle

The above-water rock is textured with both pen and brushwork providing contrast against the smoothness of the water

Area where rock and spray meet is blotted to resemble mist

light washes suggest soft shadows in the white water — Maintain lots of "white."

Underwater rock shapes are darkened with warm shadow colors and ink lines.

Water falls

Dark rock and foliage areas behind the falls provides strong value contrast.

- Pay attention to direction of water flow.
- Maintain lots of white highlight areas.
- Use subtle shading techniques for shadows, underlying rocks.

Begin by masking sun-struck white water areas with liquid frisket

Pastel, earth-tone washes are brushed over the un-masked areas of the falls—

Warm-hued washes suggest underlying rocks seen through the transparent water

Scratched-in sparkle highlights

Cool washes suggest shadows cast upon the water

The watercolor washes are accented with both India ink and liquid acrylic pen work.

Pen and ink quick sketch

Contour lines

rise

Scribble lines

35

OLD TIMER, 8½″×7″, Pen and India Ink drawing, overlaid with watercolor.

METALLIC IMPRESSIONS

"Smooth" can be a tricky texture, especially when the smooth surface is in the form of polished metal. Understanding what makes a surface look shiny can help turn a metallic problem into a fun project. To begin with, a polished surface has an abundance of white highlights. It is strong in reflective color as well as local color, with quite a wide range of hues. Color and value changes are often abrupt, representing glare, sparkle and mirror-like reflections.

Contrasting a shiny surface with a highly textured background or foreground can make the surface look even more reflective by comparison. In the painting at left, the foreground area was heavily textured with scribble lines, splatter and dog hair techniques.

Dull, tarnished metals are strong in local color, but pick up little reflected color. The local color consists of a limited palette—usually a base mixture and several tints and shades derived from it. Tarnished metals have a blended look, with color and value changes flowing softly, one shade into the next. Oxidation causes the metal to lose its luster, resulting in a subdued glow that can be represented with a few small, off-white highlights.

Rusty, aged metals can range from fairly smooth to a virtual kaleidoscope of texture in their most corroded stages. Inked scribble lines, dots and cross-hatching, combined with an imaginative use of watercolor techniques, can produce rust so real it seems to flake from the page. Rust has so many "faces" that it's hard not to depict it well. In fact, if your polished metal doesn't shine and your tarnished surface doesn't glow, dip your brush in a warm sienna mixture and corrode your metal into a rusty relic.

Cast-iron And Tarnished Metal

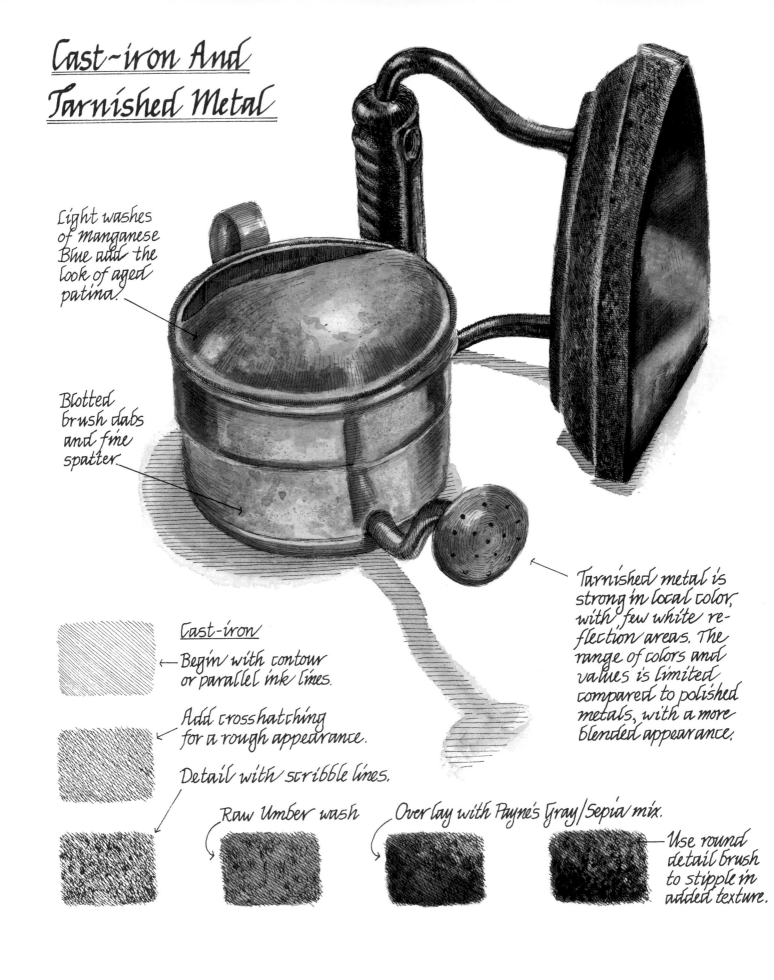

Light washes of Manganese Blue add the look of aged patina.

Blotted brush dabs and fine spatter

Tarnished metal is strong in local color, with few white reflection areas. The range of colors and values is limited compared to polished metals, with a more blended appearance.

Cast-iron

← Begin with contour or parallel ink lines.

← Add crosshatching for a rough appearance.

Detail with scribble lines.

Raw Umber wash

Overlay with Payne's Gray/Sepia mix.

Use round detail brush to stipple in added texture.

① Damp surface wash - (Indigo and Cobalt)

Brush on streaks of liquid frisket to form pattern

Deepen shadows with both pen and brushwork

Burnt Sienna rust spot.

Chipped area is darkened with pen and ink work, then overlaid with watercolor washes.

Center of chipped area is a mixture of Indigo and Raw Sienna.

Lighten areas by blotting

③ Use a clean, damp flat brush to blend and soften streaked pattern into the darker hue surrounding it.

② Brush on a second, darker layer of the Indigo/Cobalt mixture. Let dry and remove frisket.

Flaws, chipped areas and spots of rust add character.

White high lights suggest a shiny surface

The streaked design in patterned enamelware should conform to the contours of the object.

Enamelware

Preliminary damp surface wash –
(Mixture of Ultramarine Blue
and Burnt Umber)

Using wet-on-wet, free flow
techniques, daub on warm
rust colors –

- Yellow Ochre
- Raw Sienna
- Indian Red
- Burnt Sienna
- Burnt Sienna
 mixed with
 Cadmium
 Orange, Indigo,
 Ultramarine
 Blue or Alizarin
 Crimson.

Blotted
lightly with a
crumpled tissue

Heavy rust
requires lots of
texturing. Spatter,
dry brush, natural
sponge stamping
and a spray
mister were
all used to
achieve
this.

Rust

Under the influence of time,
weather and corrosion,
common metal objects can
become interesting sketching
subjects. The heavier
the rust, the more
textured and
colorful they
become.

This rusted
potato peeler was
found in a mole hill
in the author's garden.
The heavy rust was thickly
layered and crumbly.

India ink and brown
liquid acrylic were stippled
on with a 3x0 Rapidograph,
representing rust particles.

Ax blade with moderate rust

Wet-on-wet, damp and dry-brush, spatter and sponge work were all used to add "rust texture."

Puddled washes suggest rust "bleed."

Payne's Gray Liquid Acrylic contour pen lines suggest smooth metal texture.

India ink work suggests peeling paint

Beginning to rust

The toy metal truck (below), was stippled with pen and ink, then partially overlaid with watercolor washes. Earth tones of Burnt Sienna and Burnt Umber mixed with Ultramarine Blue enrich the ink work and suggest the patina of aged cast-iron, streaked with rust.

Washes were applied to a damp surface.

GASOLINE

Touches of red paint suggest the original color of the truck.

45

Damp surface bruising used to suggest tree branches.

Old machinery has a nostalgic appeal that makes it a good choice for subject matter. Old paint, dust, rust and corrosion all add to the interest.

Contour ink lines, layered damp surface washes and drybrush work provides the illusion of aged, rusty metal, seen at a distance.

Weathered metal has a dull sheen — keep highlights muted.

Scratched in highlights

Loose, scribbly ink lines add a rough, weather worn appearance.

Spots and spatter marks indicate ground textures.

Base wash ~ (damp surface)
- Burnt Sienna
- Cadmium Orange
- plus a touch of
 Ultramarine Blue

Overlay mixture
- Burnt Sienna
- Cadmium Orange
- Ultramarine Blue

Shadow mixture ~ (drybrush)
- Burnt Sienna
- Alizarin Crimson
- Violet
- muted with Indigo
 or Payne's Gray.

The barn sketch (below) is a pen and ink drawing enhanced with watercolor.

Rusty metal seen at a great distance is muted in color, with little apparent texture.

Corrugated metal roof suggested by parallel ink lines.

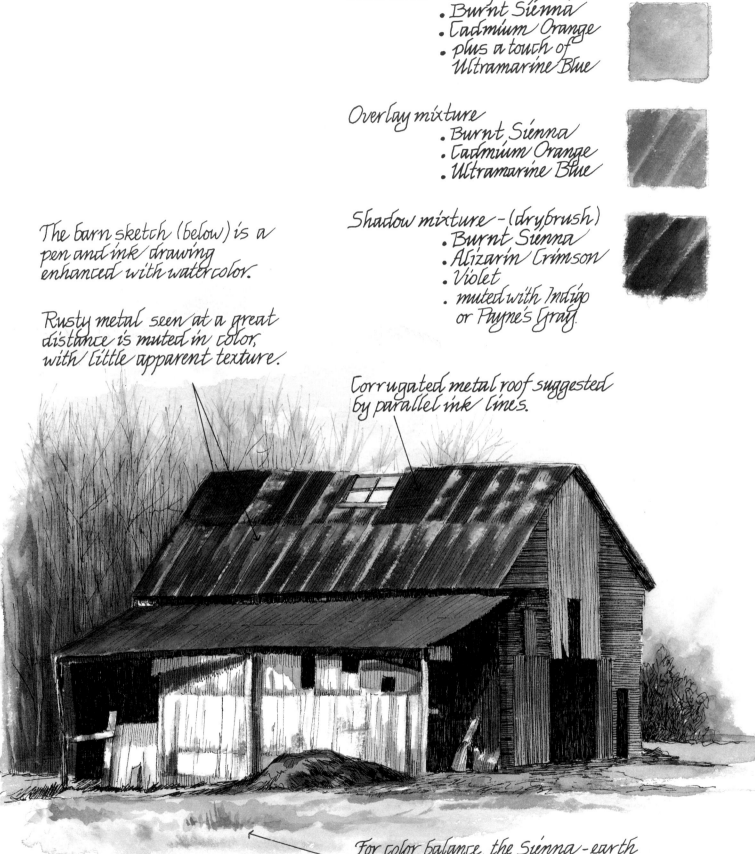

For color balance, the Sienna-earth tone mixtures are re-used in the foreground.

Soil

Most of the time soil, dirt and bare earth can be adequately represented with a damp to wet surface wash of earth-tone browns and grays, textured with a fine spattering of clear water. Deeper value, dry surface spatter and a touch of ink or liquid acrylic stippling completes the look.

Red Clay Soil

Top Soil

Dry, Dusty Soil

Rich Humus

Burnt Umber & Ultramarine mixture

1.

2.

Conifer Forest Duff

1. Begin by masking out pine needle shapes with liquid frisket.
2. Brush an earthy brown wash over the dried frisket - (damp surface).
3. Press a crumpled plastic wrap over the wet wash and let dry.
4. Rub off masking.
5. Use Sienna / Burnt Umber paint mixtures to drybrush the pine needles.
6. Finish with a touch of dark brown spatter and inked scribble lines.

Spatter

3.

4.

5.

Ink work

Damp surface washes-
(darken the value for
wet sand areas)

Wet sand is firm and
compact _ no spatter
texture here.

liquid frisket was
used to mask the
pebbles during the
preliminary washes.

Frisket spatter

Beach Sand

Scraping in a few
highlights adds the
sparkle of quartz.

Dry sand-
(lighter values)

Spatter and
pen and ink
stippling

Sand

The fine particles of
rock that make up
seashores and desert
dunes can be represented
with damp surface
washes textured
with spatter
and stippling.

Warm earth
tones

Desert Sand

Erosion
is suggested
with gullies,
drybrushed
with deep shadow
colors, and parallel
line pen work.

Stippling,
and damp and
dry surface
spatter.

Inked scribble
lines help define
small pebbles in the sandy soil.

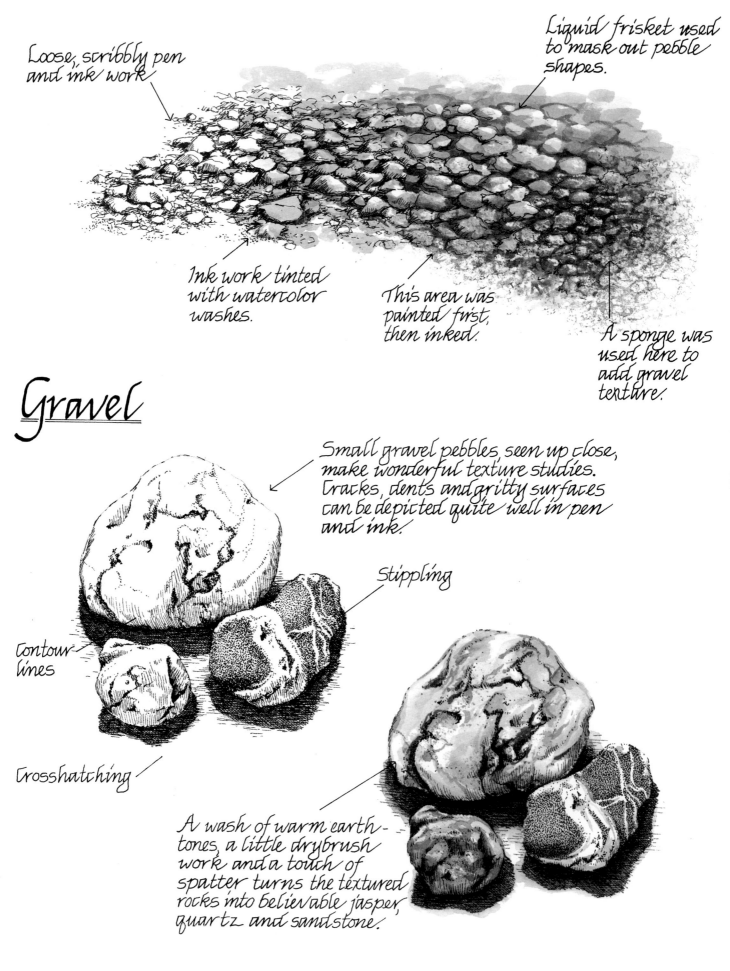

Loose, scribbly pen and ink work

Liquid frisket used to mask out pebble shapes.

Ink work tinted with watercolor washes.

This area was painted first, then inked.

A sponge was used here to add gravel texture.

Gravel

Small gravel pebbles, seen up close, make wonderful texture studies. Cracks, dents and gritty surfaces can be depicted quite well in pen and ink.

Stippling

Contour lines

Crosshatching

A wash of warm earth-tones, a little drybrush work and a touch of spatter turns the textured rocks into believable jasper, quartz and sandstone.

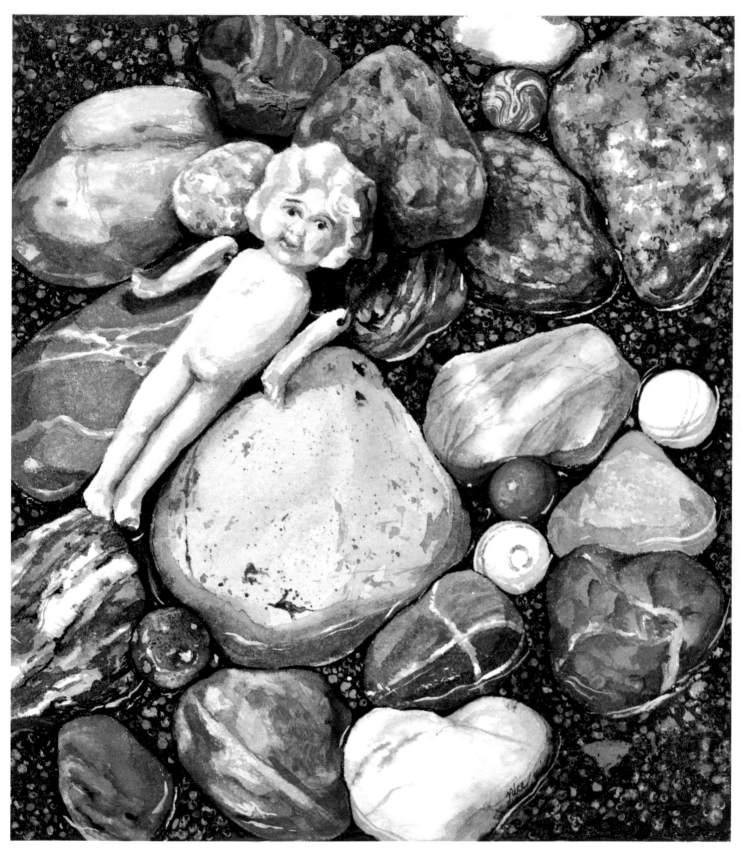

TOYS IN THE CREEK BED, 7½″ × 6½″

Tumbled, water-worn stones are smooth and rounded. Moisture enriches their color
and enhances the texture patterns on their surface. The washed gravel seen in this
painting represents a small variety of such stones. Each rock consists of several layers
of watercolor wash, textured with dry-brush work and a few pen and ink accents.
The pea gravel background was worked heavily with pen and ink scribble lines.

This craggy lava
flow, jutting from
the sea, was worked
heavily with loose, scribbly
India ink lines, then painted with
layers of watercolor wash (Burnt Umber, Burnt Sienna & Payne's Gray).

54

<u>Lichen spots</u> –
Brush alcohol into wet wash.

<u>Surface texture</u> –
Stamp dry wash with a natural sponge. Add spatter.

<u>Dry moss</u> –
Brush dark brown into neutral gray (wet-on-wet). Let dry and add criss-cross ink lines.

These distant basalt boulders were painted with layered wash techniques, allowing each wash to dry before adding the next. Spots were created with rubbing alcohol. Ink lines were used to deepen the shadows.

This rough surface piece of basalt is further textured with lichen, dirt and dry moss.

Volcanic Rocks

This cliff-dwelling scene was sketched with a 3x0 Rapidograph, filled with Brown liquid acrylic, then overlaid with water-color washes.

At a distance, the gritty texture of sandstone is not apparent. Contour lines, crosshatching, and scribbling defines form and a smoother texture.

fossils — (drybrush & pen work).

Sandstone

Pebbles in the conglomerate sandstone were masked out during the base wash.

The gritty texture of sandstone can be well represented by damp and wet on wet washes, enhanced with dry-brush work, spatter and pen and ink stippling.

Wet-on-wet

Drybrush

Stippling

Adobe & Brick

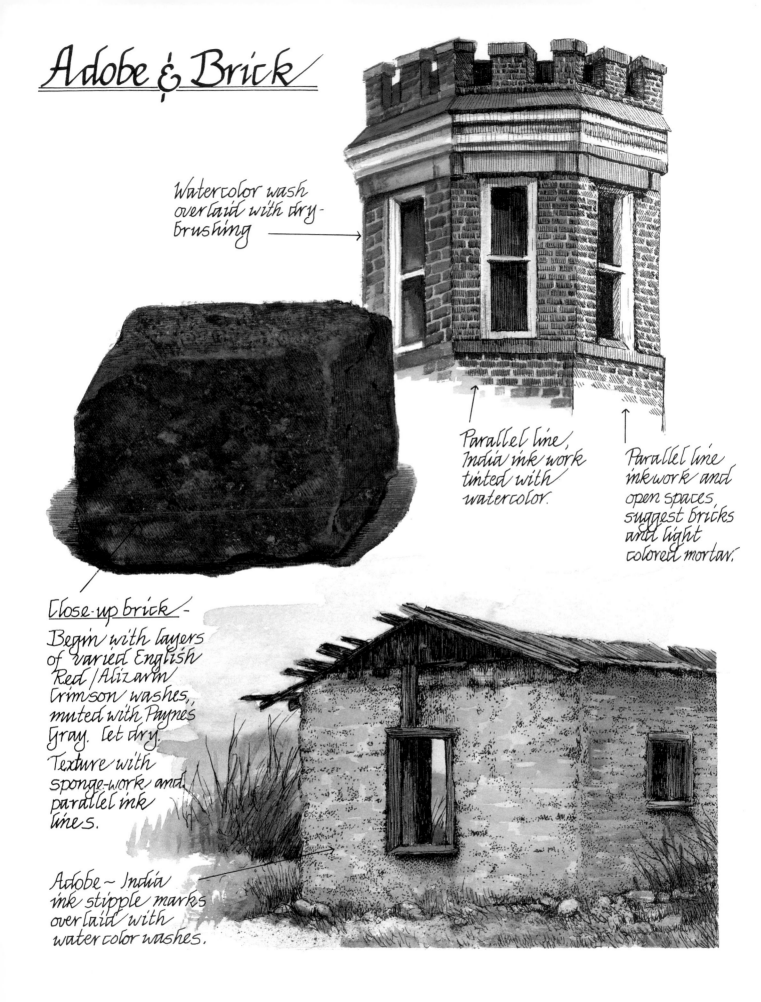

Watercolor wash overlaid with dry-brushing

Parallel line, India ink work tinted with watercolor.

Parallel line ink work and open spaces, suggest bricks and light colored mortar.

Close-up brick –
Begin with layers of varied English Red / Alizarin Crimson washes, muted with Payne's Gray. Let dry. Texture with sponge-work and parallel ink lines.

Adobe ~ India ink stipple marks overlaid with water color washes.

Stone Masonry

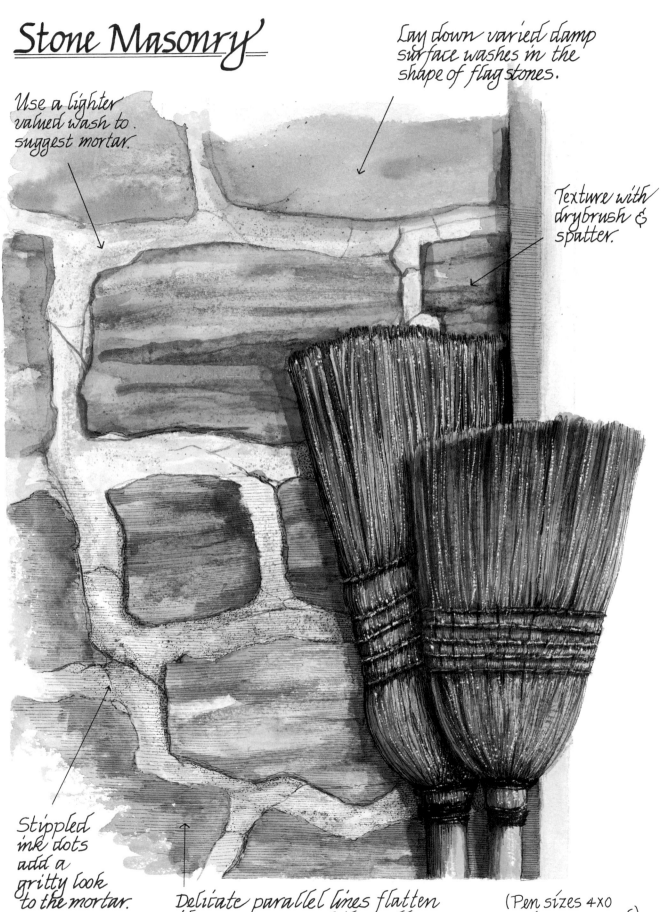

Use a lighter valued wash to suggest mortar.

Lay down varied damp surface washes in the shape of flagstones.

Texture with drybrush & spatter.

Stippled ink dots add a gritty look to the mortar.

Delicate parallel lines flatten the appearance of the wall.

(Pen sizes 4x0 and 3x0 were used)

Scribble - line moss area

① Begin with a scribbly, rough textured ink sketch.

Cross hatching

Parallel line

A (0) size pen nib was used here.

② Tint rocks with earth tone washes of cool and warm colors.

③ Add drybrush shadows and spatter.

Moss area was enhanced with liquid acrylic criss cross pen strokes.

Stone Walls

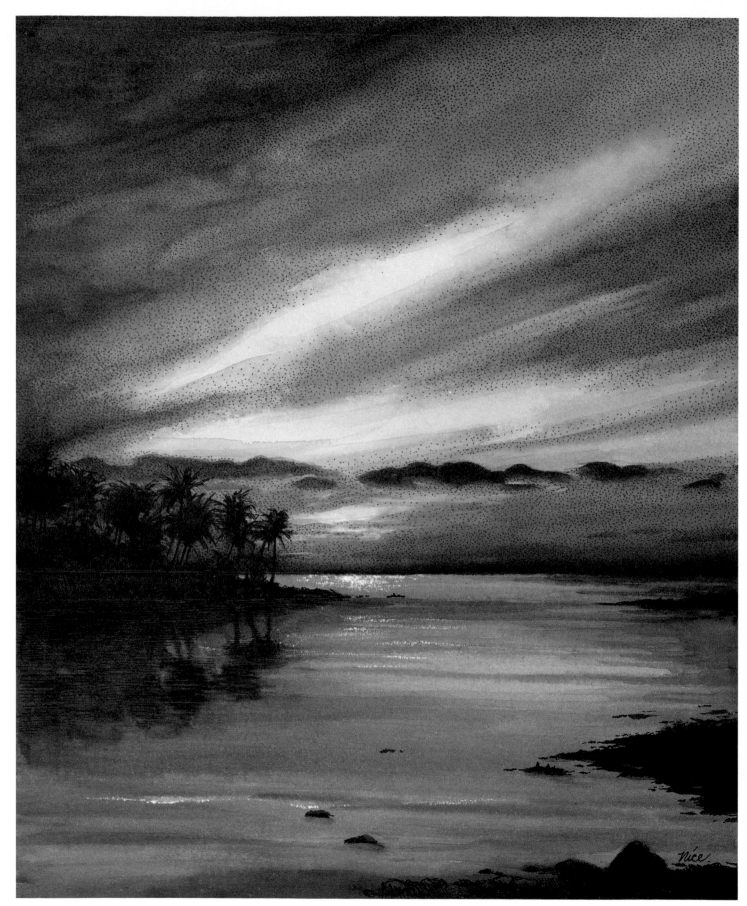

TROPICAL SUNSET, 8⅝″×7″, Watercolor, pen and ink, pen and ArtistColor.

SKIES AND WEATHER

The sky is often portrayed as a calm, blue, hardly noticed backdrop. However, when clouds pile up into fluffy mountains or march troop-like in ominous formations or burn the heavens with reflected color, there is enough drama to catch our full attention. No other subject is quite as changeable or challenging as a cloud, whose elusive nature can be both thick, dark and threatening, and as delicately transparent as silken cobwebs.

To maintain the fragile aspect of clouds, I begin my sky depictions with wet-on-wet watercolor washes. As darker values are stroked in place, pastel or unpainted areas form spontaneous cloud shapes with soft, naturally blended edges. This process is not complete until the paper is dry. Don't be afraid to blot in a few highlights, re-align a shape with a damp brush or change the flow with a spray mister. However, keep in mind that overworking wet wash areas can result in water flow marks, puddling and muddy, tired paper. When something pleasing happens, leave it alone! Values can be darkened, color highlighted, and additional cloud formations added once the initial wet-on-wet work is completely dry. Stroke the additional washes *lightly* over the surface so as not to disturb the underlying paint. Gently blend the moist edges with a clean, damp brush.

The last step is to decide if the addition of pen work would benefit the composition. A bit of stippling can add textural interest to a cloud formation—defining the shape and deepening the shadows. Parallel lines provide strong definition and create the appearance of wind, rain and movement. If India Ink is too harsh, use colored inks or liquid acrylic. Yes, even a plain blue sky can be texturally exciting when enhanced with the stroke of a pen.

Here, the damp washes were spray misted to form a lacy edge.

Parallel line pen strokes suggest a sky with little wind.

The summer skies on this page were created using wet-on wet water color techniques. Unpainted areas formed spontaneous clouds.

Delicate wavy line pen work suggests wind movement.

(Process Cyan Artist Color was used in a 3X0 Rapidograph)

Cumulus Clouds

These white cloud areas were formed by blotting the damp wash with a crumpled tissue.

The edge of these clouds were masked, then softened by scraping with a razor blade.

Stippled pen work adds definition to shadow areas.

Rain Clouds

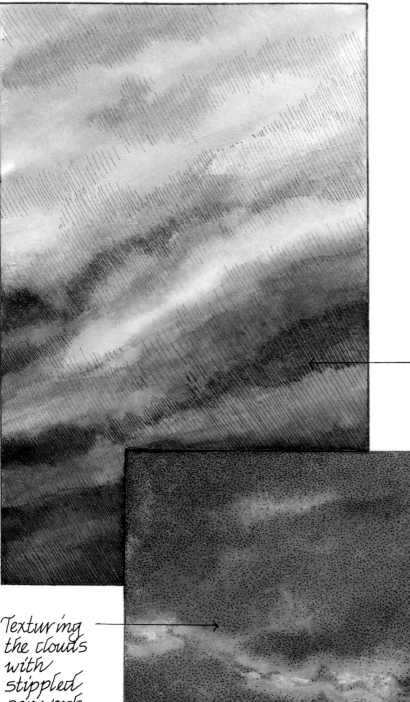

Nimbus (rain) clouds consist of moisture laden stratus (layered) clouds, heaped up cumulus clouds or a mixture of both.

Begin painting these rain cloud formations with wet-on-wet washes of varied values. Use dark violet/Payne's gray mixtures against pale grays, pastels and white unpainted areas, for drama and contrast.

Diagonal, parallel pen strokes worked over the dry washes, suggest wind and rainfall.

Texturing the clouds with stippled penwork adds a bold, heavy quality to the scene.

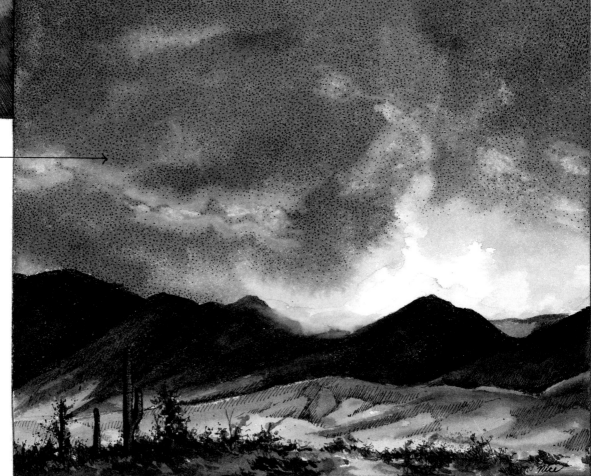

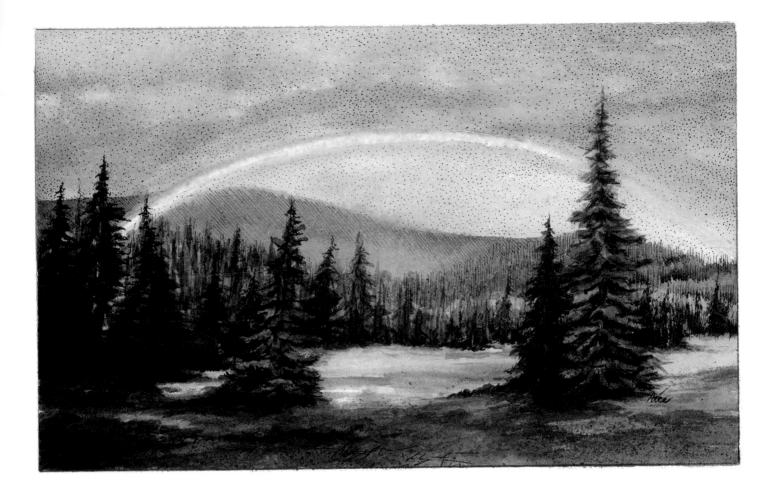

Rainbows

① Lay down a damp surface wash of pale yellow. Let dry.

② Add a pale red-orange stripe to the top of the bow, and a blue-green and lavender stripe to the bottom. Blend with a damp, detail brush. ⟶

③ Moisten the areas above and below the arc and lay in a wet-on-wet cloud formation. ⟶

Accent the clouds with stippled pen work.

(3x0 above arc & 4x0 below)

Area below arc is lighter in value.

Diagonal pen strokes accent cloud formations and suggest rainfall direction.

Fan brush used to suggest rainfall. (drybrush)

Thunderstorms

Use wet-on-wet techniques to create dark, ominous storm clouds, leaving lightly painted areas for contrast. Let dry.

Drybrush additional, dark cloud formations into place. Soften the edges with a clean, damp brush.

Lightning bolts are masked with liquid frisket. (Fine lines were scratched in with razor.)

Snow

A winter sky, sprinkled with delicate snowflakes, has no need for further texturing with the ink pen.

Salt reacts especially well in washes of Payne's Gray, producing white, fluffy flakes.

Tree branches rendered in pen, ink and drybrush were carefully added around the snowflakes.

Foreground snowflakes were scratched in.

Sunset

Begin with pastel, wet-on-wet watercolor washes. While the paper is still moist, add darker cloud shapes. Let dry. <u>Don't over work</u>!

Additional clouds can be added using drybrush and damp brush blending techniques.

Diagonal, parallel ink lines add texture, definition and an upward lift to the horizontal cloud formations.

Mixtures of Payne's Gray, Indigo, Blue-Violet and Sepia, accented with pen work, make good silhouettes.

Black silhouettes tend to look stiff and unnatural.

Bodies of water reflect the coloration of the sunset.

white areas blotted
with a tissue.

This sunrise is a simple wet-on-wet
watercolor wash – no inkwork added.

In brighter skies, the
careful use of penwork
over dry washes will
add focus to the
clouds. _____

Brown pen stippling ⟶

Payne's Gray penwork ⟶

India Ink detailing ___

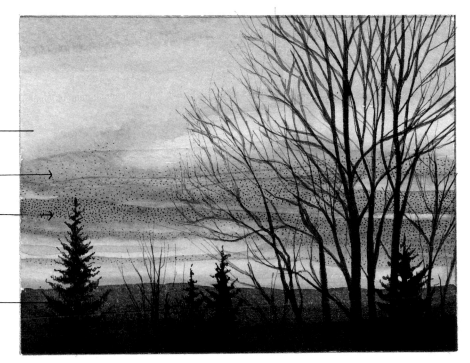

Sunrise

Traditionally, the sunrise has been thought of
as pastel and delicate. In truth, the sunrise can
rival the sunset in coloration.

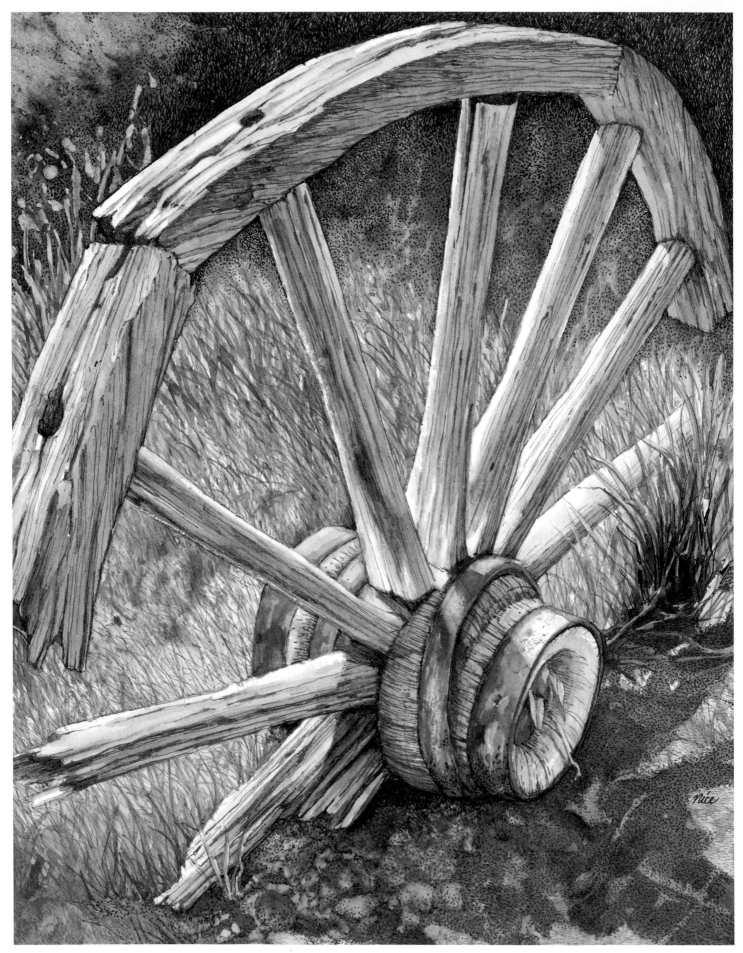

ALONG THE TRAIL, 9″×7″, Watercolor, pen and ink, pen and ArtistColor.

WOOD GRAIN PATTERNS

There is something nostalgic about wood, especially old weathered wood. Like the wrinkles on an old face, each crack and grain line bespeaks of bygone memories and stories untold. Creating wood grain is almost as much fun as the memories it inspires . . . and there's more than one way to do it.

The most obvious way to duplicate the grain of wood is to draw it in, using pen and ink, or for a more subtle look, pen and liquid acrylic. Wavy lines are the ideal stroke. If the lines appear too bold, blend and soften them as soon as they are laid down, with a moist brush. If you're using India Ink, you must be quick.

One can also drybrush the grain lines in, over layered washes, using a fan brush or the tip of a round detail brush. In a moist wash, bruising is very effective.

There are lots of artistic tricks to further age and weather that old fence post or paint-peeled barn board. Experiment with spatter, salt and alcohol techniques and the introduction of contrasting earth tones, using the spontaneous flow of wet-on-wet.

Rusty nails, spots of lichen and washes of green algae or moss also add to the weathered, corroded look. However, keep in mind that distance will dictate how much detail is needed. While little wood grain is seen in the faraway fence, up close only the imagination can limit the amount of texture portrayed.

Wood Grain

Continuous or broken wavy line pen strokes are ideal for depicting the grain patterns of cut wood.

The design patterns depend upon the wood type and how the wood was cut.

This block of Hemlock wood was textured with Brown pen work and overlaid with watercolor.

Crosscut

Cut with the grain

← Rough wood - Use a larger size nib and sketchy strokes.

Smooth wood - Use a fine nib (4x0 or 3x0) and precise, flowing pen strokes. →

← India ink tinted with watercolor →

② Dry fan brush work

③ Additional washes are laid on and blended with a clean, damp brush.

① Damp surface wash

Walnut wood

④ Wood grain texture lines are added using pen and ink.

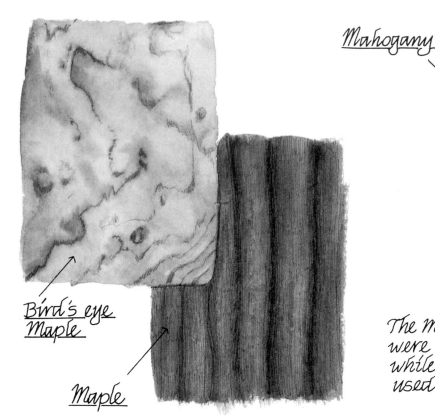

Mahogany

Bird's eye
Maple

Maple

The Mahogany and Oak wood grains
were penned with India ink,
while Brown liquid acrylic was
used to texture the lighter woods.

Watercolor washes may
be added before or
after the pen work.

Watercolor spatter

The pen work in the
Maple and Cedar
sketches were stroked
promptly with a damp
brush to blend and
soften their appearance.

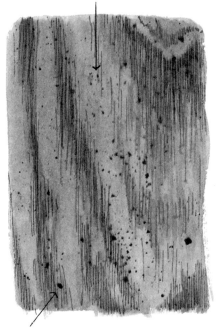

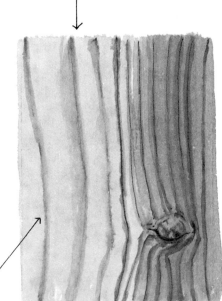

Distressed Ash Wood

Cedar

Oak

A fan brush
was used here
for additional
texture.

Bruising is an
additional method
of creating a realistic
wood grain
appearance

1. Begin with a varied
damp surface wash.

2. Using a wavy line
pattern, bruise the
paper with a stylus.

3. If desired,
accent with a
little brown
pen work.

Layered washes,
textured with
dry brush and
pen and ink.

Bruised wood grain,
created with stylus.

Polished Wood

like shiny metal, polished wood has strong value patterns and lots of reflective color.

Muted highlights (reflected color)

Reflected color

A few wavy pen lines "suggest" rather than depict the wood grain.

White highlights

Liquid acrylic cross-hatching adds textural interest to the foreground.

Wood seen at a distance is depicted more by color than detailed grain work.

Varied damp surface wash.

Dry brush wood grain and shadows

Masked with liquid frisket

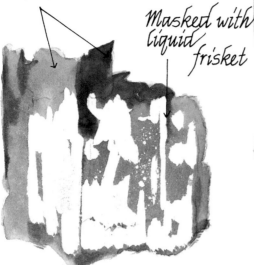

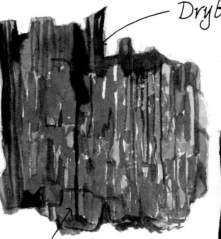

Brown liquid acrylic in 3x0 Rapidograph

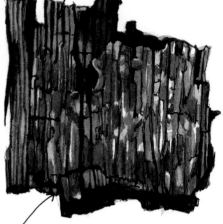

Lay in old paint areas.

Deep cracks defined with pen and India ink.

Weathered Wood ~
Old Paint

Begin with damp surface, off-white wash.

While still damp, brush in brown, wavy line streaks.

Use round brush to detail wood grain, cracks, holes and shadows.

Spatter provides textural variety.

Add fine details with pen—

Wood grain stroked with India ink.

Paint cracks were penned using earth tone liquid acrylic.

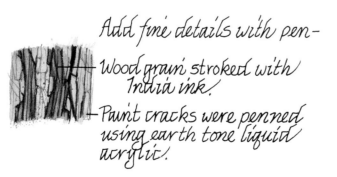

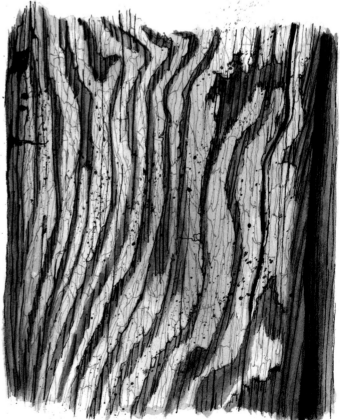

Aged Fencing

Pen work:

scribble

Wavy line

At a distance, wooden fencing is portrayed simply, with just a hint of drybrush and pen and ink detailing.

Seen up close, texture becomes very important.

The weathered wooden post (left) was textured heavily with pen and ink, then further enhanced with watercolor washes, drybrush, spatter and fine splashes of alcohol.

Driftwood

The texture of driftwood varies from very rough to the smooth, satin finish of aged, water worn wood.

Wavy line, pen and ink work, overlaid with watercolor washes.

The wood grain lines were detailed with Payne's Gray liquid acrylic in a 00 Rapidograph, then tinted lightly with watercolor.

Alcohol stroked into a wet wash.

Varied watercolor washes were laid in first.

Subtle grain lines were added using Brown liquid acrylic in a 3x0 pen. Blend with a damp brush.

Spatter

Watercolor washes of Payne's Gray, stippled with ink work, suggests sand.

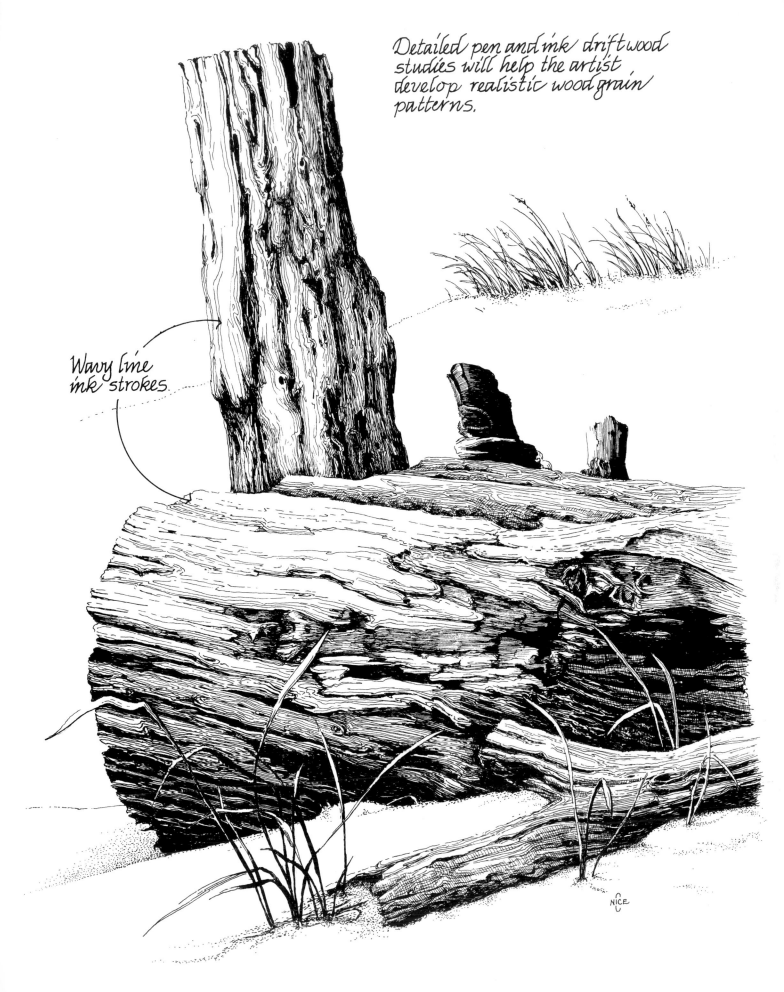

Detailed pen and ink driftwood studies will help the artist develop realistic wood grain patterns.

Wavy line ink strokes.

NICE

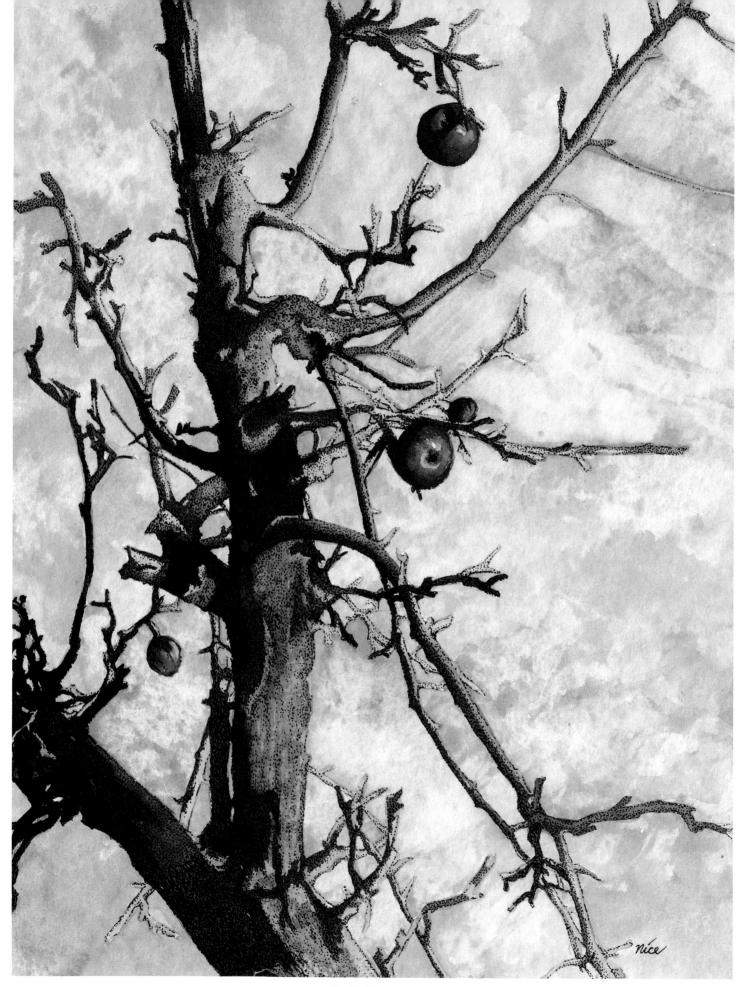

WINTER APPLES, 9⅜″×7″, Watercolor, India Ink pen work.

CHAPTER EIGHT

TREE TECHNIQUES

Rare is the landscape without trees or shrubbery of some sort. They are as natural and important to the outdoor scene as sky and earth.

Close up, trunks, limbs and leaves can be as full of texture as the artist desires. Alcohol fungus spots, clumps of salt-technique moss, and spattered age spots add spontaneous, textural fun to the detailed tree. The thickest, roughest bark or the finest net of leaf veins can all be suggested and enhanced with the stroke of a pen.

On the other hand, most landscape trees are seen at a distance, where their entire shape is evident. Now the artist must sacrifice some of the close-up details and textures. Scribble lines become the standard for creating leaf groupings, and color and overall shape go a long way in suggesting the age, species and season of each tree. As trees recede into the distance, lines become simpler and the colors more muted.

Although trees are made up of many parts and endless textures, don't let them become overwhelming.

Conifer Tree Bark

Trees in the evergreen family tend to have heavily textured bark. The old timers sport deep creases and plate-like folds that are perfect to sketch in pen and ink.

The Conifers on this page were rendered in India ink, then tinted with watercolor.

Crosshatching

Scribble

Spruce Burl

Scribble lines

Salt technique patterns suggest moss.

Spatter

Douglas Fir

Wavy lines

Cedar

Scribbly wavy lines

Sugar Pine

Old Broadleaf Maple –

Painted with varied water-color washes and texturing techniques, accented with pen and ink.

Bruising

Leaves were masked out with liquid frisket.

Table salt

Wavy line pen strokes

Scribble lines

Spatter

Contour lines

Vine Maple Sapling –

Textured with Payne's Gray pen work, then tinted with water-color washes.

Hardwood Tree Bark

The broadleaf, deciduous trees vary greatly in bark color and texture.

The barks of some species change significantly with age.

Don't hesitate to try out various technique mixtures.

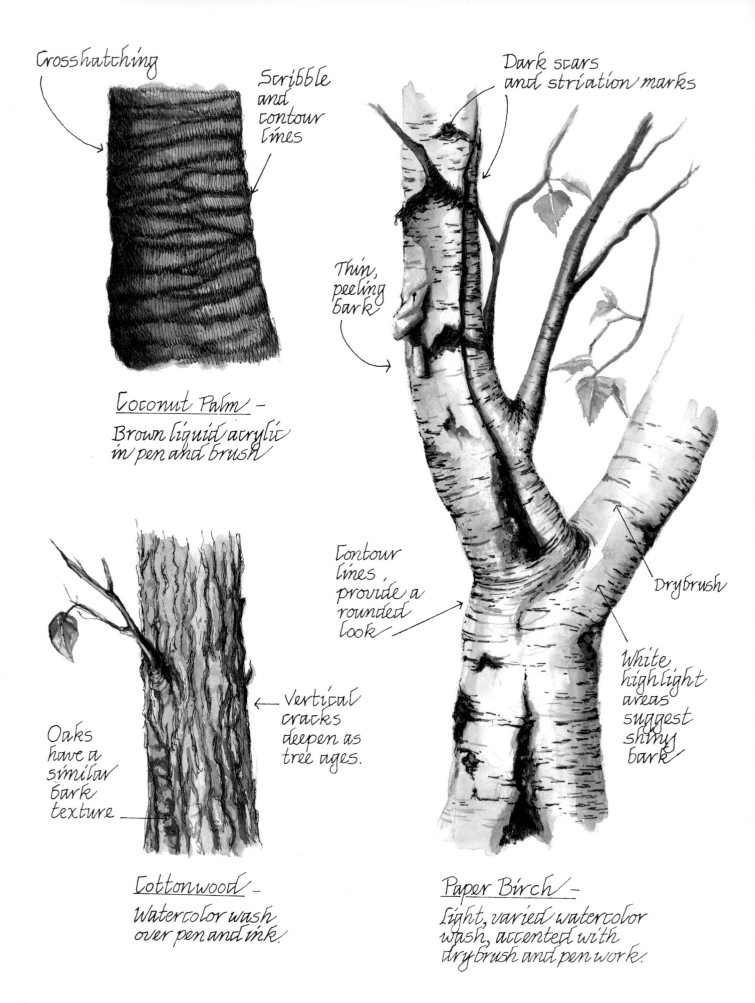

Crosshatching

Scribble and contour lines

Coconut Palm –
Brown liquid acrylic in pen and brush

Dark scars and striation marks

Thin, peeling bark

Contour lines provide a rounded look

Drybrush

White highlight areas suggest shiny bark

Oaks have a similar bark texture

Vertical cracks deepen as tree ages.

Cottonwood –
Watercolor wash over pen and ink.

Paper Birch –
Light, varied watercolor wash, accented with drybrush and pen work.

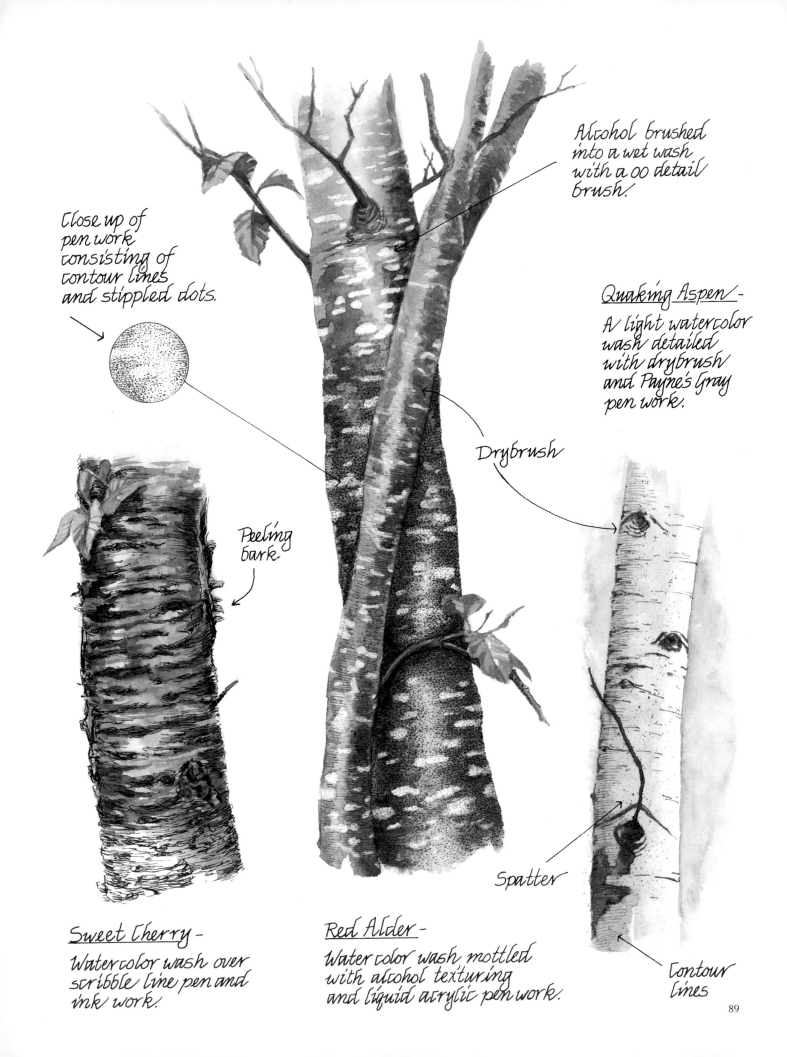

Close up of pen work consisting of contour lines and stippled dots.

Alcohol brushed into a wet wash with a 00 detail brush.

Quaking Aspen -
A light watercolor wash detailed with drybrush and Payne's Gray pen work.

Drybrush

Peeling bark

Sweet Cherry -
Watercolor wash over scribble line pen and ink work.

Red Alder -
Watercolor wash mottled with alcohol texturing and liquid acrylic pen work.

Spatter

Contour lines

89

Roots

These root studies began as highly detailed pen and ink drawings. Contour lines depict tangled, weather-worn roots, while rough and mossy areas are suggested with crosshatching and scribble lines.

Maintain light value areas when adding washes.

Sepia, Payne's Gray and Sienna mixtures accent the pen and ink work.

Bright watercolor washes add richness.

Contour lines

scribble

crosshatch

Nice

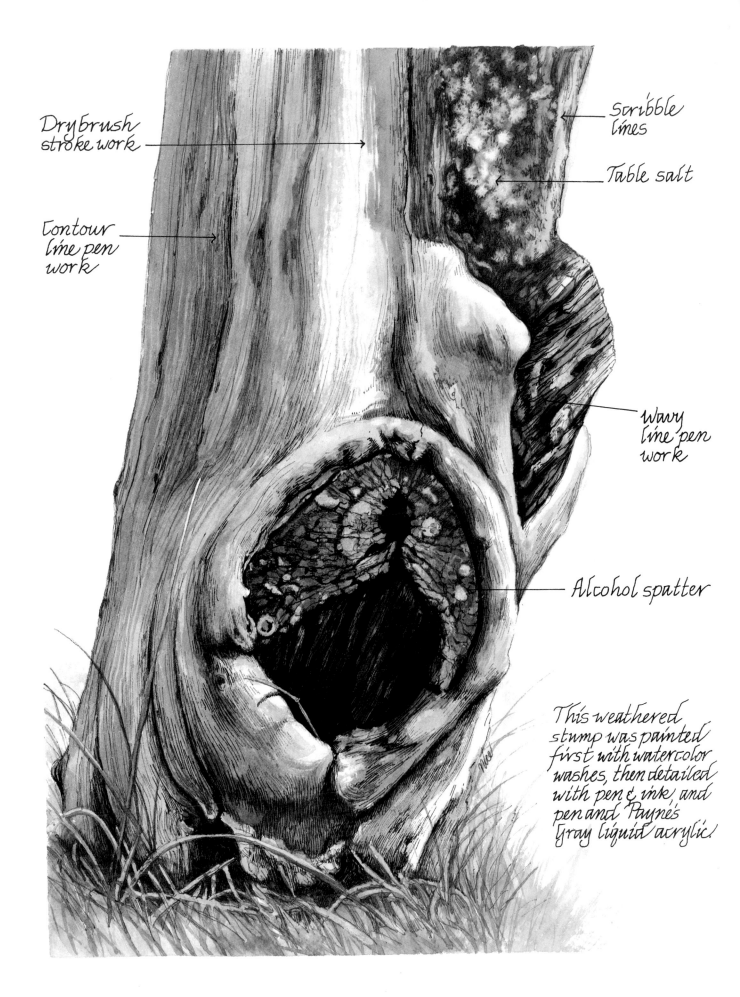

Dry brush stroke work

Contour line pen work

Scribble lines

Table salt

Wavy line pen work

Alcohol spatter

This weathered stump was painted first with watercolor washes, then detailed with pen & ink, and pen and Payne's Gray liquid acrylic.

Branches

Winter is the best time to study the shape and texture of tree branches. Ice, painted like clear glass, can add contrast and textural variety to the sketch.

The background of this winter scene is painted wet-on-wet, then over-laid with parallel line ink work in Payne's Gray liquid acrylic.

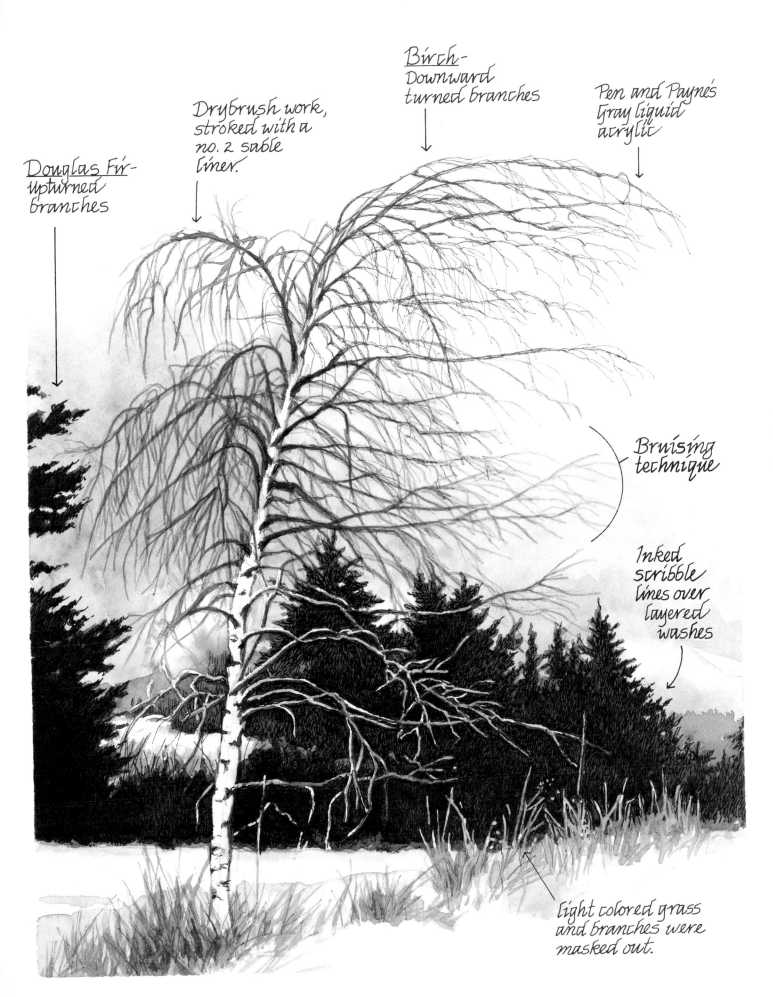

Birch-
Downward
turned branches

Drybrush work,
stroked with a
no. 2 sable
liner.

Pen and Payne's
Gray liquid
acrylic

Douglas Fir-
upturned
branches

Bruising
technique

Inked
scribble
lines over
layered
washes

Light colored grass
and branches were
masked out.

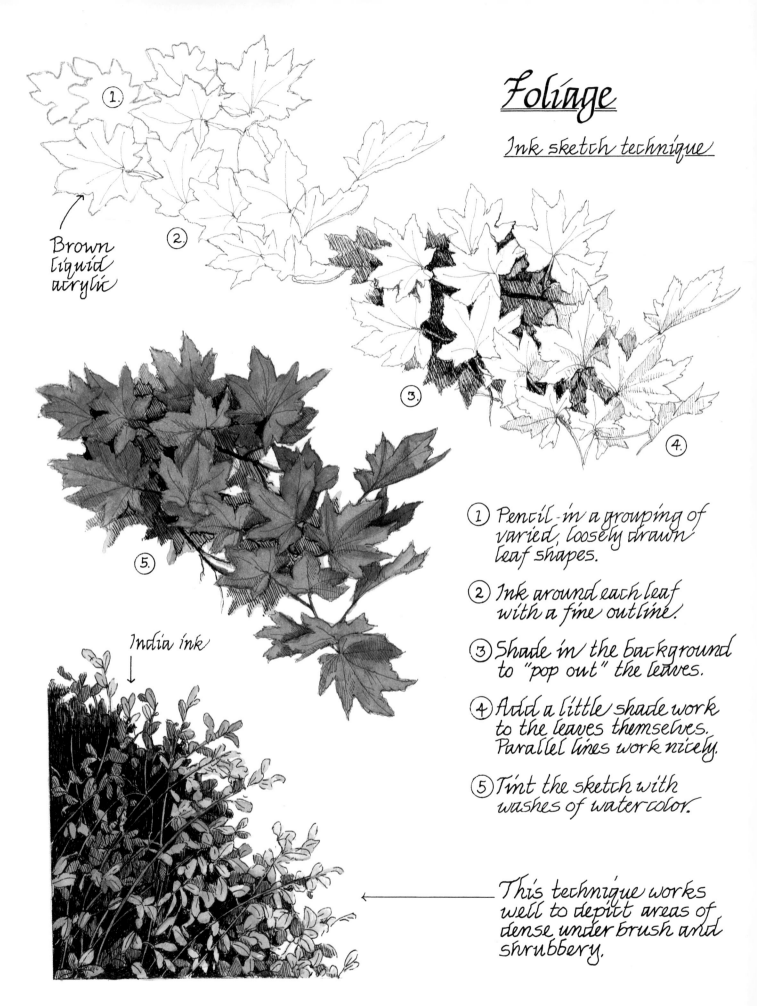

Foliage

Ink sketch technique

(1).

Brown
liquid
acrylic

(2).

(3).

(4).

(5).

India ink

1. Pencil-in a grouping of varied, loosely drawn leaf shapes.

2. Ink around each leaf with a fine outline!

3. Shade in the background to "pop out" the leaves.

4. Add a little shade work to the leaves themselves. Parallel lines work nicely.

5. Tint the sketch with washes of water color.

This technique works well to depict areas of dense under brush and shrubbery.

Impressed texturing
Crumpled plastic wrap pressed into a wet wash until dry creates leaf-like designs.

Drybrush stroke work

Pen and liquid acrylic detail work - parallel lines.

Pen and ink detailing

Spatter
A fine, delicate foliage can be produced quickly using a combination of spatter and flat brush stippling. Use an old frayed brush for this.

Drybrushing
The tip of a no. 4 round detail brush is perfect for stroking in pine needles.

Sponge stamped foliage

1. Suggest the trunk shape with a damp surface wash.

2. Using a damp sea sponge brushed with pigment, stamp in the foliage layers, beginning with the lightest hue.

3. Use drybrushing to detail the trunk and create branches.

4. Pen and ink detail work added.

Distant Trees

At a distance, individual leaves become less important than overall tree shape, texture and color. Value contrasts and limited detail work are still important.

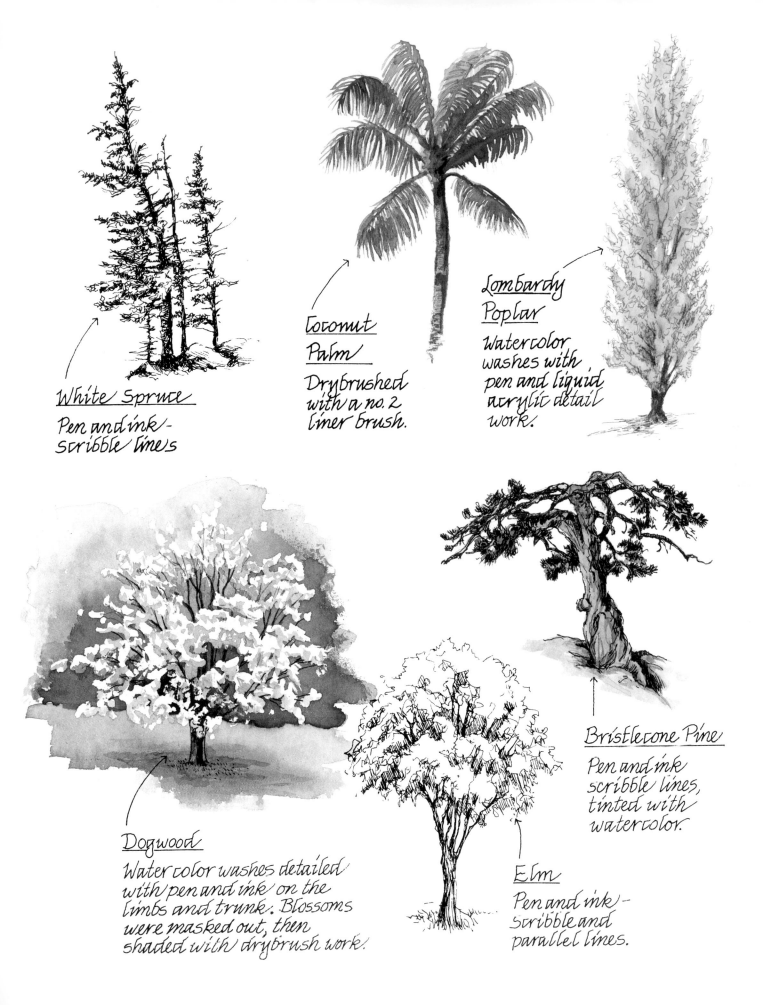

White Spruce

Pen and ink -
scribble lines

Coconut
Palm

Drybrushed
with a no. 2
liner brush.

Lombardy
Poplar

Watercolor
washes with
pen and liquid
acrylic detail
work.

Dogwood

Water color washes detailed
with pen and ink on the
limbs and trunk. Blossoms
were masked out, then
shaded with drybrush work.

Elm

Pen and ink -
scribble and
parallel lines.

Bristlecone Pine

Pen and ink
scribble lines,
tinted with
watercolor.

Background Trees

As trees recede farther into the distance, texture is flattened, color is muted and shape is merely suggested.

Pencil sketch of basic pine tree shape.

Parallel line ink texturing.

Shadows added.

Watercolor wash added.

Weeping Willow

Muted watercolor wash overlaid with Payne's gray pen work.

Parallel ink lines tinted with color

Crosshatching

Background forest of mixed trees and shrubs.

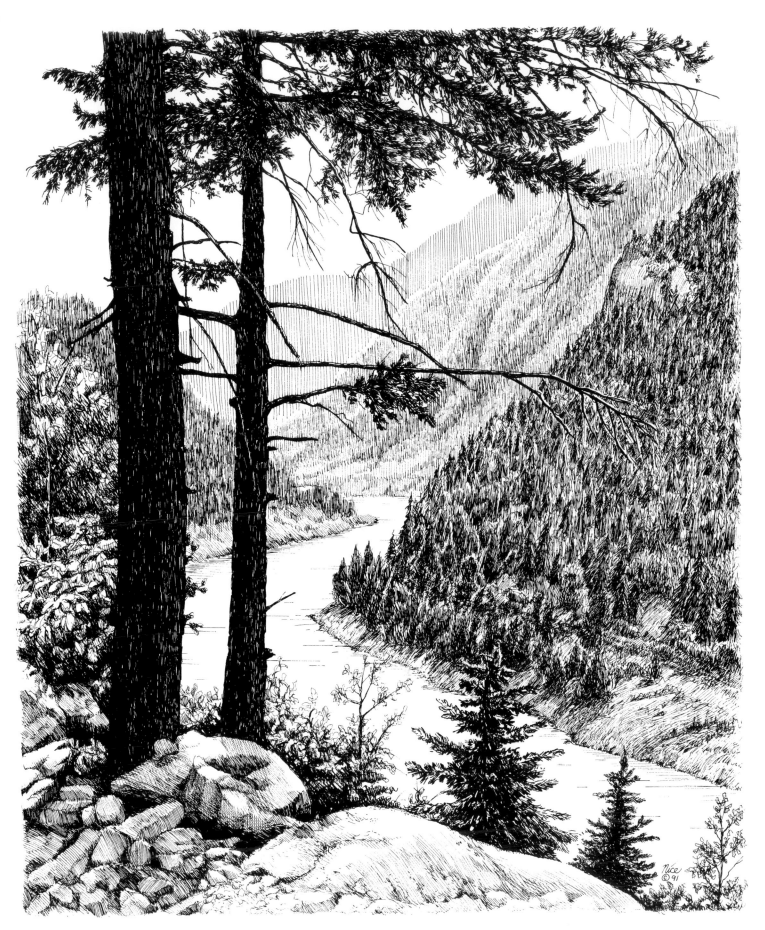

A PLACE FOR VISION QUESTS, 9″×7¼″

Note the difference between foreground and background textures and values in
this pen and ink landscape. Rapidograph sizes 1, 3×0, and 4×0 were used.

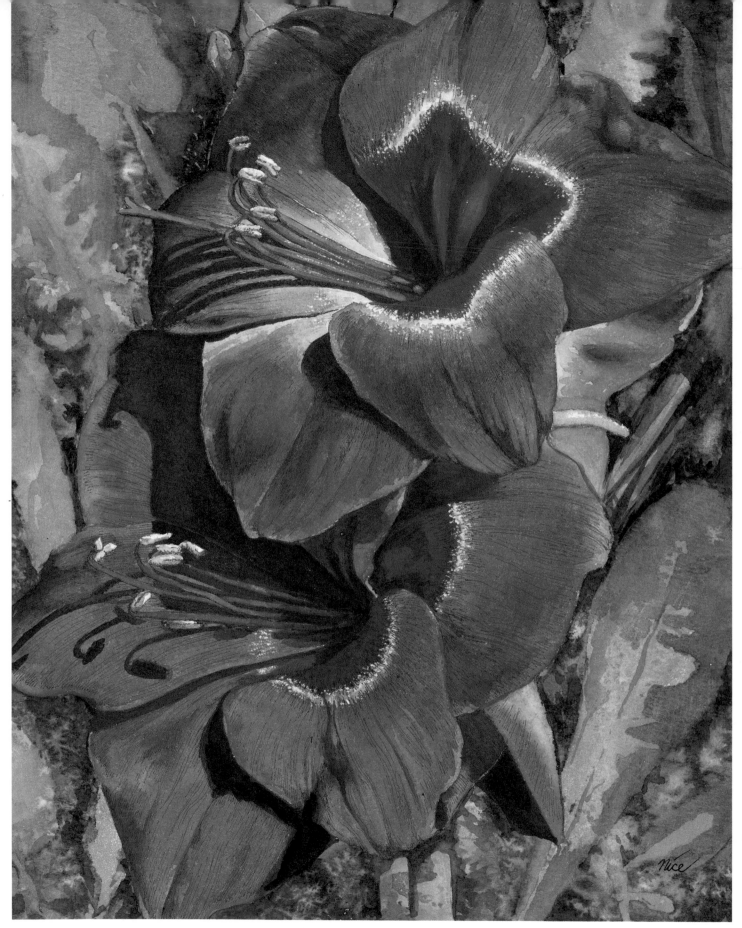

AMARYLLIS, 10″×7½″, Watercolor, liquid acrylic pen work.

TRANSLUCENT FLORALS

Capturing translucence on paper is a little like trying to hold the wind in your hand. Just when you think you have it, you add a bit too much pressure (or paint) and poof!—you've lost it. Indeed, the secret of painting translucence is knowing when to stop!

I usually begin my multimedia blossoms with a damp surface or wet-on-wet watercolor wash. Often, the way the pigment pools or flows will suggest my next step. Exciting, spontaneous effects can happen during this stage. Accept them as a gift and don't disturb them.

It's important to maintain lots of pale-hued areas to suggest the light filtering through the petals. Shadows showing through from beneath the petals will also help to depict translucence. Don't be afraid to lay in additional layers of bright color, but let each layer dry before adding the next. Tired paper results in tired, worn-looking flowers. Shiny blossoms need white paper highlights to suggest their high-gloss reflections. For final touches of detail and texture, Rapidograph pen strokes and liquid acrylic work well. Keep it delicate.

Not all florals are translucent. Petals of rich velvet, tangled umbral flower heads and sprays of tiny jewel-like blooms, along with weeds, grasses and fungus flora call for textural creativity. Spatter, blotting, impressed textures, salt, alcohol, stamping, stippling or a combination may provide the answer. The background of the floral at left was textured with wet-on-wet washes, negative dandelion leaf prints and salt technique. The blossoms are made up of layered washes, dry brush and liquid acrylic contour pen lines. A few unusual texture experiments are shown in this chapter. A multitude more need only be tried!

Floral Pen Sketches

To maintain a delicate look when pen sketching flowers, choose a fine nib size (6x0 - 3x0) and avoid solid, harsh outlines.

Use contrast of value and texture to create natural definition where possible.

Pansies

Dots suggest a velvet texture.

Liquid acrylic pen work over a light wash of the same medium.

Wavy lines depict a vein-like pattern

Roses

Contour lines produce smooth, graceful petals.

Preliminary pencil sketch

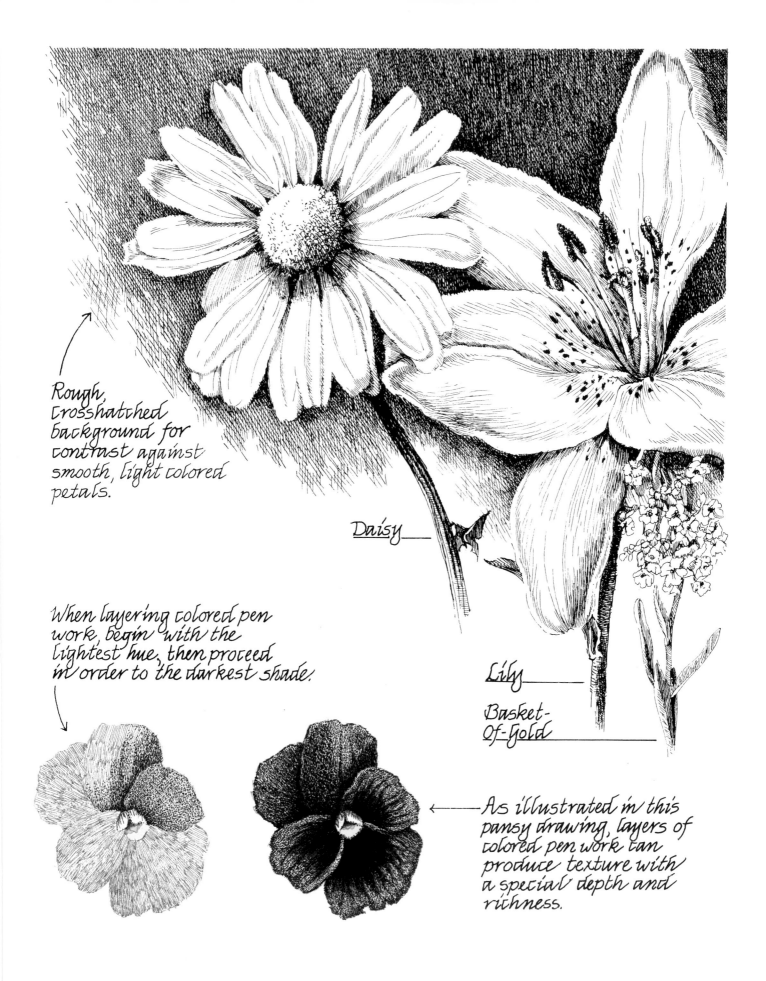

Rough, crosshatched background for contrast against smooth, light colored petals.

Daisy

Lily

Basket-Of-Gold

When layering colored pen work, begin with the lightest hue, then proceed in order to the darkest shade.

As illustrated in this pansy drawing, layers of colored pen work can produce texture with a special depth and richness.

Varied Floral Textures

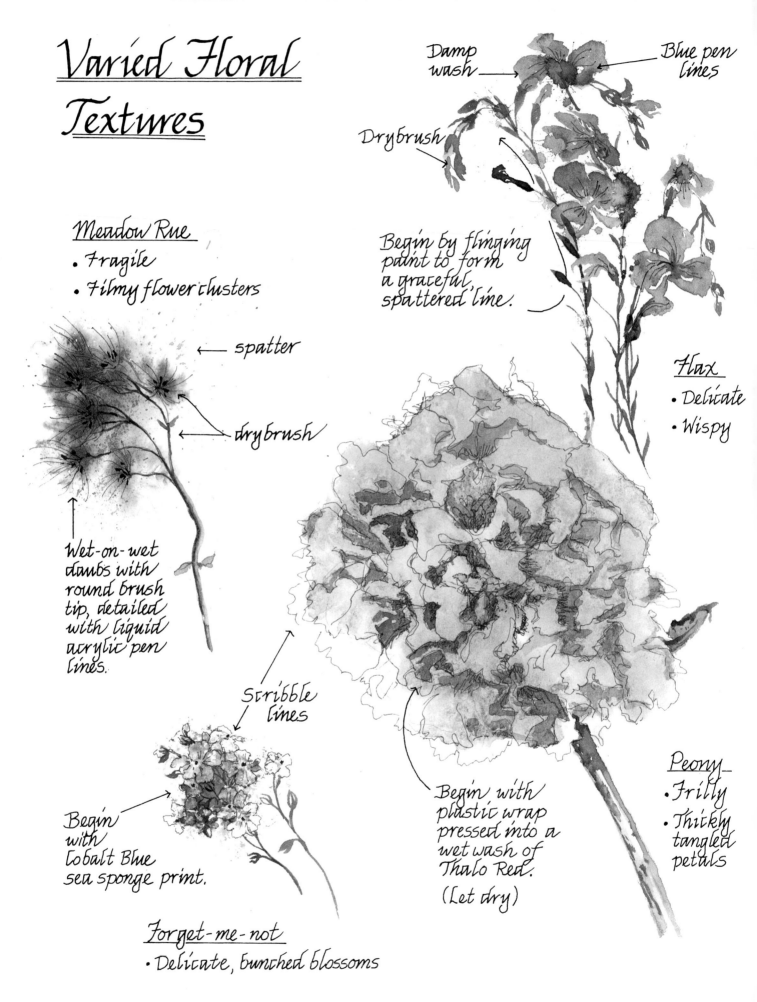

Damp wash

Blue pen lines

Drybrush

Begin by flinging paint to form a graceful, spattered line.

Meadow Rue
- Fragile
- Filmy flower clusters

← spatter

← drybrush

Wet-on-wet daubs with round brush tip, detailed with liquid acrylic pen lines.

Flax
- Delicate
- Wispy

Scribble lines

Begin with Cobalt Blue sea sponge print.

Begin with plastic wrap pressed into a wet wash of Thalo Red.

(Let dry)

Peony
- Frilly
- Thickly tangled petals

Forget-me-not
- Delicate, bunched blossoms

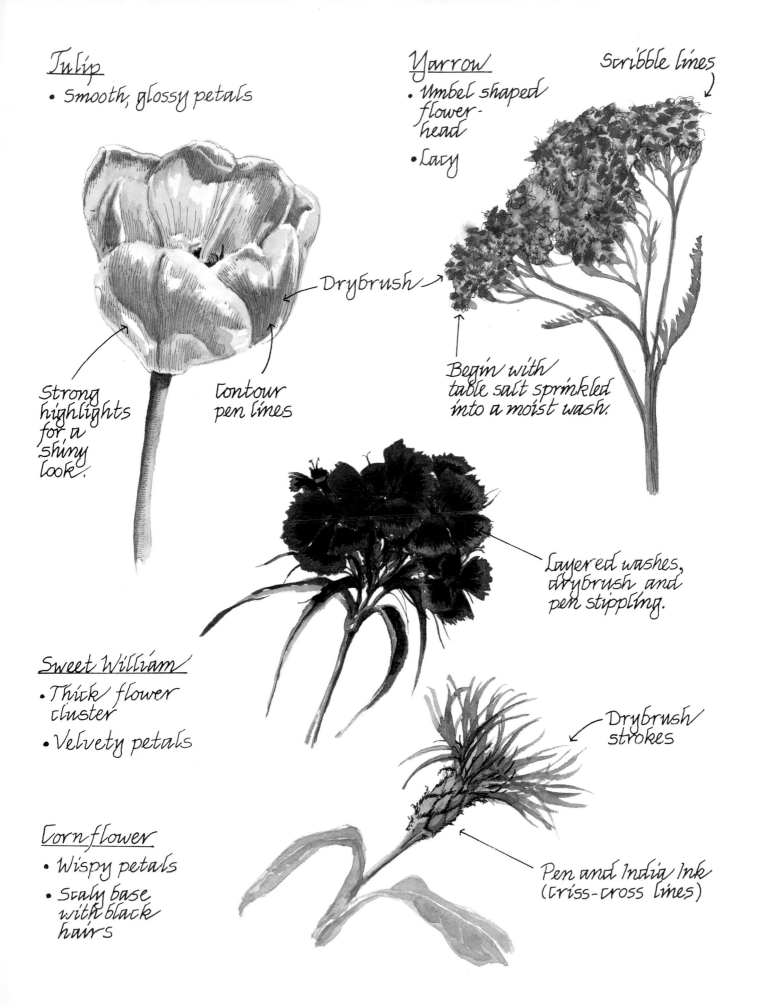

Tulip
- Smooth, glossy petals

Yarrow
- Umbel shaped flower-head
- Lacy

Scribble lines

Drybrush

Strong highlights for a shiny look.

Contour pen lines

Begin with table salt sprinkled into a moist wash.

Layered washes, drybrush and pen stippling.

Sweet William
- Thick flower cluster
- Velvety petals

Drybrush strokes

Cornflower
- Wispy petals
- Scaly base with black hairs

Pen and India Ink (criss-cross lines)

Leaf Textures

Leaves are as varied in size, shape and texture as the flowers they feed. All seven pen strokes are useful in their portrait, as well as numerous watercolor techniques.

The following leaf examples are merely suggestions—

Pen and ink contour lines

Mixed media rose leaf-

① Begin with a pencil sketch and a light watercolor wash. (Thalo Yellow Green / Chromium Oxide Green)

Light blue-green sheen area.

Blotted area

② Lightly outline the veins with pen work and crosshatch the areas between.

(Payne's Gray liquid acrylic)

③ Drybrush on a second wash of Hooker's Green Deep / Payne's Gray, leaving some of the previous paint layer to show through. Add as much drybrush shade work as desired.

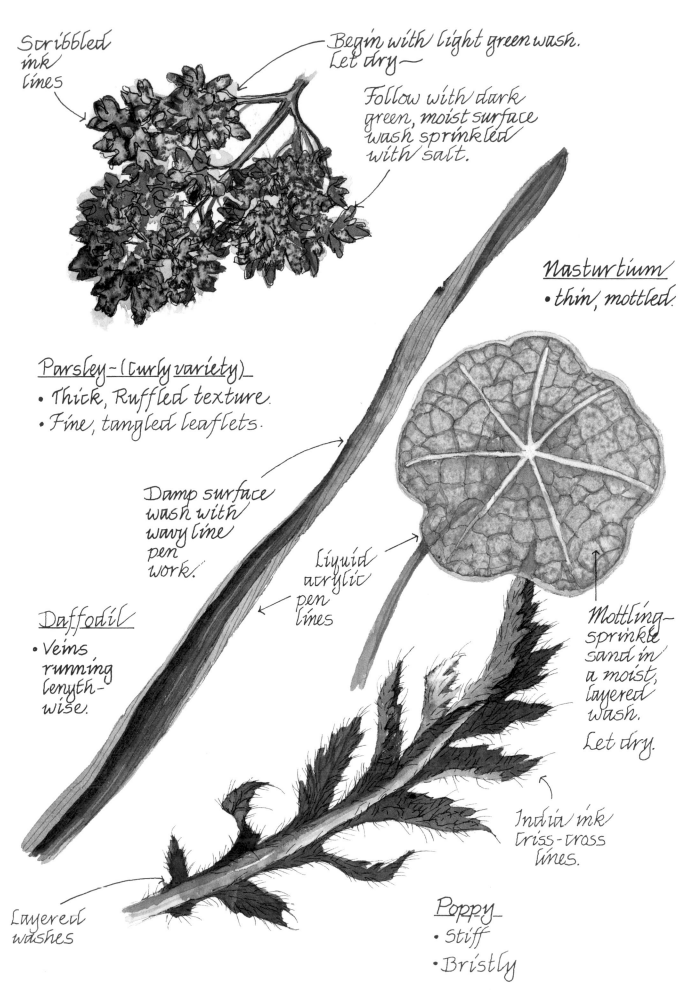

Scribbled ink lines

Begin with light green wash. Let dry—

Follow with dark green, moist surface wash sprinkled with salt.

Nasturtium
• thin, mottled.

Parsley – (curly variety)
• Thick, Ruffled texture.
• Fine, tangled leaflets.

Damp surface wash with wavy line pen work.

Liquid acrylic pen lines

Daffodil
• Veins running length-wise.

Mottling-sprinkle sand in a moist, layered wash.

Let dry.

India ink criss-cross lines.

Layered washes

Poppy
• Stiff
• Bristly

Weeds And Grasses

The earthy colors and varied textures of grasses and weeds combine to make them exceptional close-up studies.

stamped with edge of flat brush

Drybrush

Pen lines

Sponge print on a damp wash surface, followed by Brown, scribbly pen lines.

Spatter

Brown liquid acrylic in a 3x0 Rapidograph pen.

Grass blade leaf print

Ink detail lines

Distant fields are depicted with simple washes, brushed while still damp with a few strokes of varied color. (horizontal)

Add vertical drybrush strokes to suggest detailed grass areas.

Frayed flat brush

Liner brush

Fan brush

Light areas were masked during wash applications.

Stamped with edge of flat brush

Sea sponge drag marks.

Criss-cross pen work

Both spring and winter grass areas began as wet-on-wet washes.

Spatter

Moss And Ferns

Fragile Fern ⟵

Both moss and ferns have a delicate appearance and a rich green coloration that almost seems to glow. However, their textures differ greatly. Mosses are usually thick, fluffy mats, while most ferns are thin leafed, lacy plants.

① Scribbled pen and ink sketch.

② Tint with Sap Green wash.

③ While still damp, lay in additional earthy greens and browns.

④ Deepen the shadows with more scribbly ink lines.

Polypody Fern

These two ferns are prints from actual leaves which were brushed with water color and pressed to damp paper.

This print was further enhanced with watercolor washes and drybrush detailing.

112

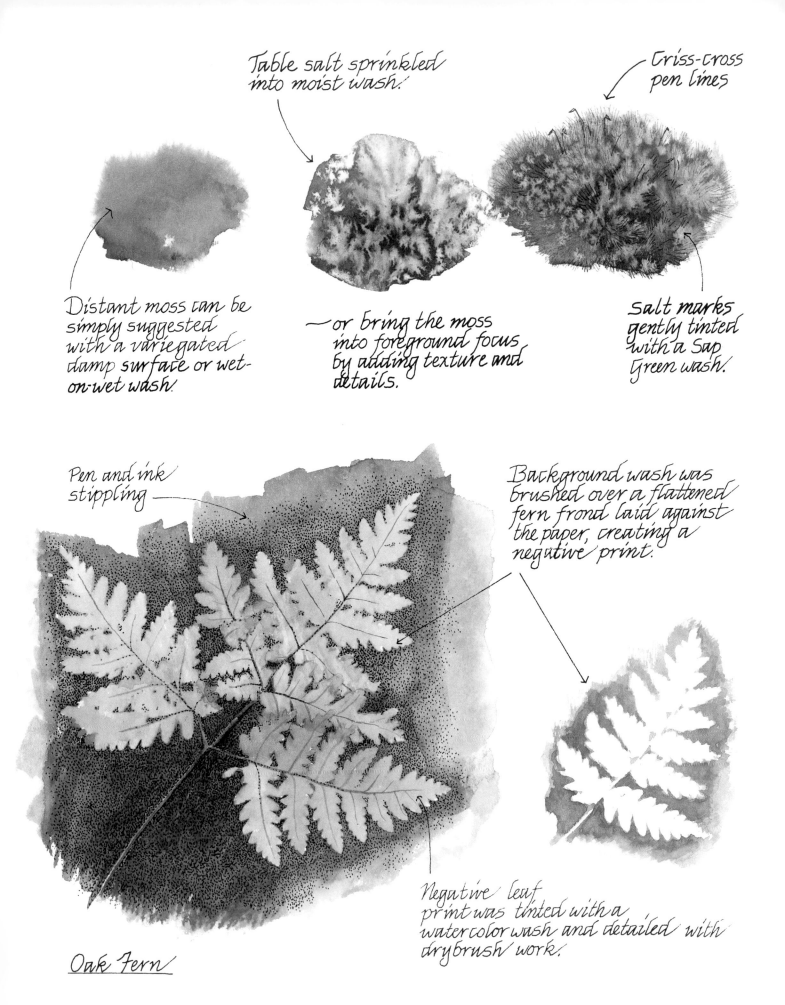

Table salt sprinkled into moist wash.

Criss-cross pen lines

Distant moss can be simply suggested with a variegated damp surface or wet-on-wet wash.

— or bring the moss into foreground focus by adding texture and details.

Salt marks gently tinted with a Sap Green wash.

Pen and ink stippling

Background wash was brushed over a flattened fern frond laid against the paper, creating a negative print.

Negative leaf print was tinted with a water color wash and detailed with drybrush work.

Oak Fern

Lichen

Appearing in many forms and earthy hues, lichen is a natural excuse to add a bit of color or bold texture to a rock or aged piece of wood.

① Begin by masking out the ruffled lichen shape and adding a simple wash.

~ Or lay in the wet surface wash first and draw the lichen shape with alcohol.

Pixie Cups →

Shield Lichen →

② Detail the lichen patches with additional washes, drybrush work and Rapidograph scribble lines.

Spatter

Wavy ink lines

Alcohol ring

Liquid frisket

— At a distance, lichen loses its lacy look, appearing as light colored spots and patches.

③ Detail the surrounding areas with drybrush and pen work.

Add as much texture as you desire as long as there remains good contrast between the lichen and background.

Mushrooms

The typical mushroom texture is smooth and rounded, with a matte to glossy sheen. Many have a translucent glow.

The mushrooms sketched here are a combination of Brown liquid acrylic pen work, layered washes and drybrush detailing.

Meadow Mushrooms

Wavy lines

Contour lines

White patches were masked while the basic wash layers were applied.

White paper sheen marks

Fly Agaric Mushrooms

Drybrush and pen detail work.

Variegated Milky Mushrooms

Yellow Morel Mushrooms

Morel fold crevices were created with plastic wrap pressed into varied, moist washes and left to dry. Details were added with drybrush and pen.

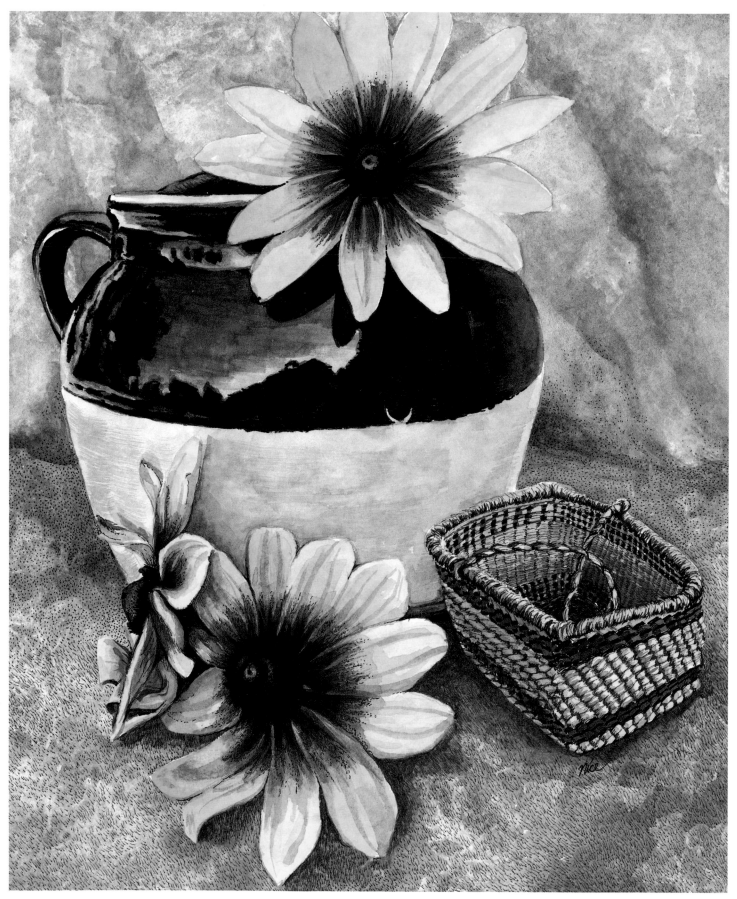

CROCK, NOOTKA BASKET, AND GLORIOSA DAISIES, 9½″ × 7¾″, Pen and ink, pen and ArtistColor, watercolor.

STILL LIFE STRATEGIES

When I think of a still life, visions of florals, fruits and earthy knick-knacks come to mind. Artists have arranged still lifes and painted from them for centuries, and the subject never seems to get old. However, some arrangements are definitely more exciting than others. The exceptional still life will be a well-designed composition, with a natural balance of shapes, pleasing colors and value contrasts. There will also be a variety of textures. Creative texturing can bring an ordinary inanimate arrangement to life.

Note the abundance of texture in the composition on the facing page. The highly glazed crock, the dusty, matte finished flower petals, and the tightly woven basket are set against the soft folds of crushed velvet, which was painted with Cobalt Blue, then blotted with a crumpled tissue. Take away the texture and the still life would be sadly lacking.

Most of the textures shown in this chapter began as preliminary washes, to which secondary layers and drybrush detailing were added. Pen work, with India Ink, liquid acrylic or both, was introduced as a final touch of texture. When the design pattern is the main focus of an object, as often seen in basketry, native pottery and sea shells, the bold texture of pen work is important and is laid down before the watercolor work.

I have only been able to show a few of my favorite still life objects in this chapter. Vegetables, which are handled very much like fruit, can be fun to explore. Think of the bumpy surface of an ear of corn, the layered crispness of lettuce and the rough, scarred surface of an old gourd. What textures come to your mind? Start with those and see where it leads you.

Fruit

Soft, blotted highlight for satin sheen.

① Start by laying in varied, damp surface washes.

Blemishes add a natural look to fruit.

White paper highlight for glossy look.

Spatter

Use complementary colors for shadows —

Yellow-green, add a touch of red-violet.

Orange-red, add a little blue-green.

② When nearly dry, gently brush on additional layers, letting each one almost dry before adding the next. Stroke in a contour direction.

③ Finish with subtle, contour pen lines in liquid acrylic to accentuate shape without harshness.

Apple —
Permanent green light pen work.

Criss-cross ink lines.

Nectarine —
Bordeaux Red pen work.

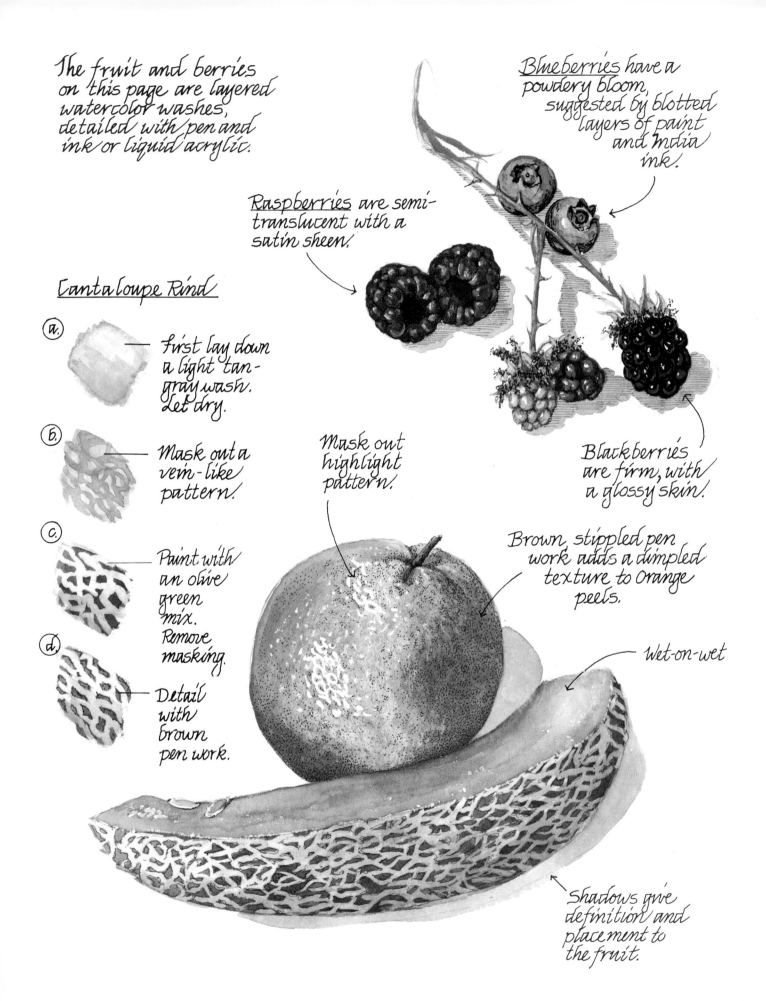

The fruit and berries on this page are layered watercolor washes, detailed with pen and ink or liquid acrylic.

Blueberries have a powdery bloom, suggested by blotted layers of paint and India ink.

Raspberries are semi-translucent with a satin sheen.

Cantaloupe Rind

a. First lay down a light tan-gray wash. Let dry.

b. Mask out a vein-like pattern.

c. Paint with an olive green mix. Remove masking.

d. Detail with brown pen work.

Mask out highlight pattern.

Blackberries are firm, with a glossy skin.

Brown stippled pen work adds a dimpled texture to orange peels.

Wet-on-wet

Shadows give definition and placement to the fruit.

Eggs And Onions

The papery skinned onion and the porcelain-like egg share a delicate, brittle quality that provides a unique challenge to the artist. The key is soft, subtle shade work and simplicity.

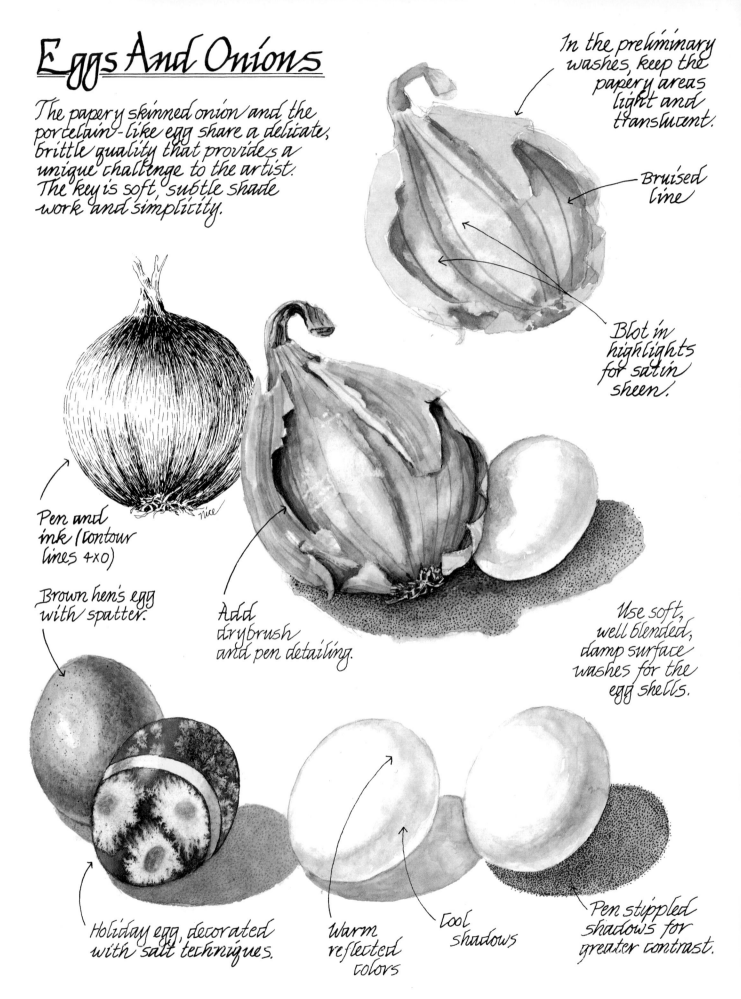

In the preliminary washes, keep the papery areas light and translucent.

Bruised line

Blot in highlights for satin sheen.

Pen and ink (contour lines 4x0)

Brown hen's egg with spatter.

Add drybrush and pen detailing.

Use soft, well blended, damp surface washes for the egg shells.

Holiday egg, decorated with salt techniques.

Warm reflected colors

Cool shadows

Pen stippled shadows for greater contrast.

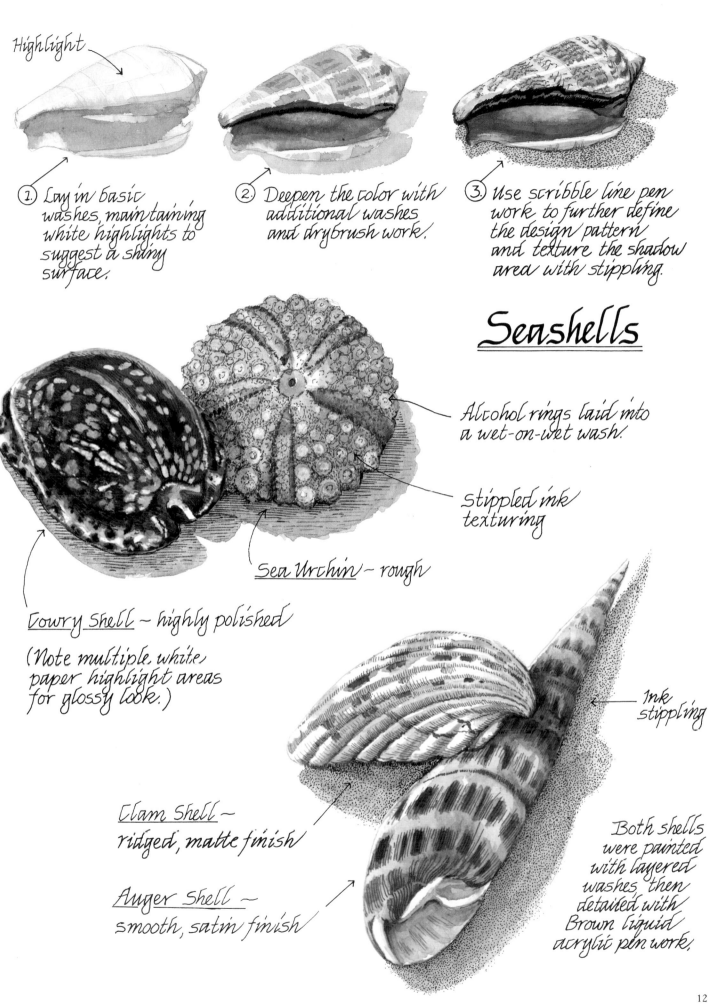

Highlight

① Lay in basic washes, maintaining white highlights to suggest a shiny surface.

② Deepen the color with additional washes and drybrush work.

③ Use scribble line pen work to further define the design pattern and texture the shadow area with stippling.

Seashells

Alcohol rings laid into a wet-on-wet wash.

stippled ink texturing

Sea Urchin - rough

Cowry Shell - highly polished

(Note multiple white paper highlight areas for glossy look.)

Ink stippling

Clam Shell - ridged, matte finish

Auger Shell - smooth, satin finish

Both shells were painted with layered washes, then detailed with Brown liquid acrylic pen work.

Textiles

Mask out stitches and paint later with ochre.

Burnt Umber / Ultramarine Blue mix.

Texture the denim with Payne's Gray or India ink, wavy line pen work.

Lay the preliminary damp surface wash on heavy, and blot with a crumpled tissue for a stone washed look.

Deepen shadows with damp surface blending techniques and Payne's Gray paint.

Braided outline

Loose cross-hatching

Mask out print design while background material is painted. Use damp surface blending techniques and blotted highlights

Worn Denim

Ribbed Knit

India ink pen work, tinted with watercolor.

Define the floral print with drybrush and pen work.

Cotton Print Fabric

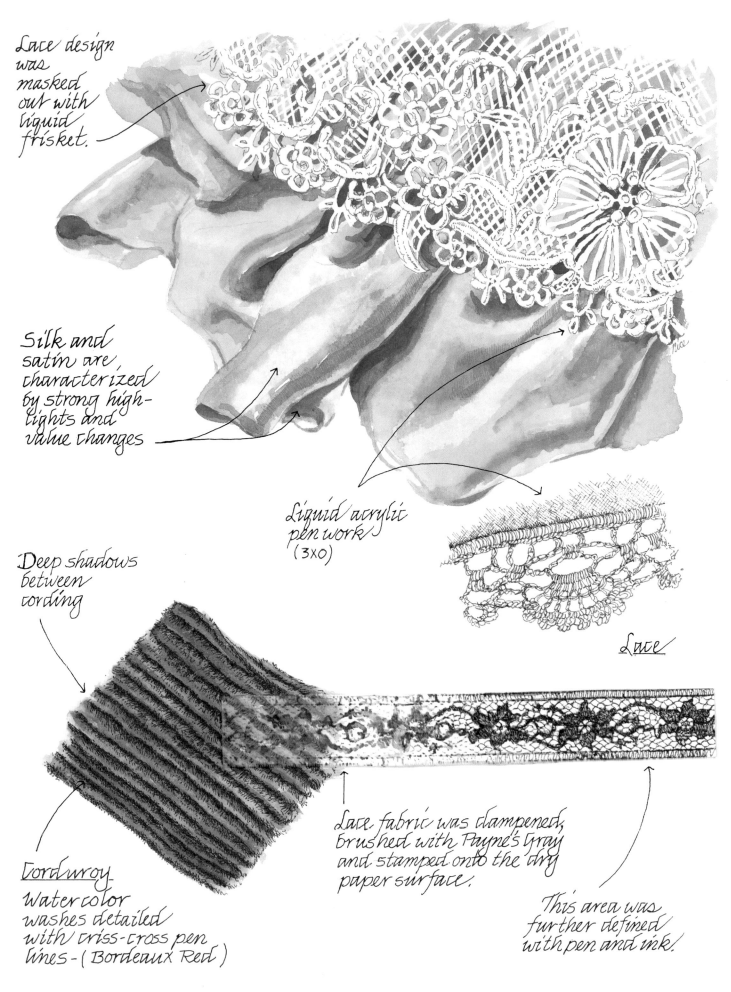

Lace design was masked out with liquid frisket.

Silk and satin are characterized by strong highlights and value changes

Liquid acrylic pen work (3x0)

Deep shadows between cording

Lace

Corduroy
Water color washes detailed with criss-cross pen lines - (Bordeaux Red)

Lace fabric was dampened, brushed with Payne's Gray and stamped onto the dry paper surface.

This area was further defined with pen and ink.

Basketry

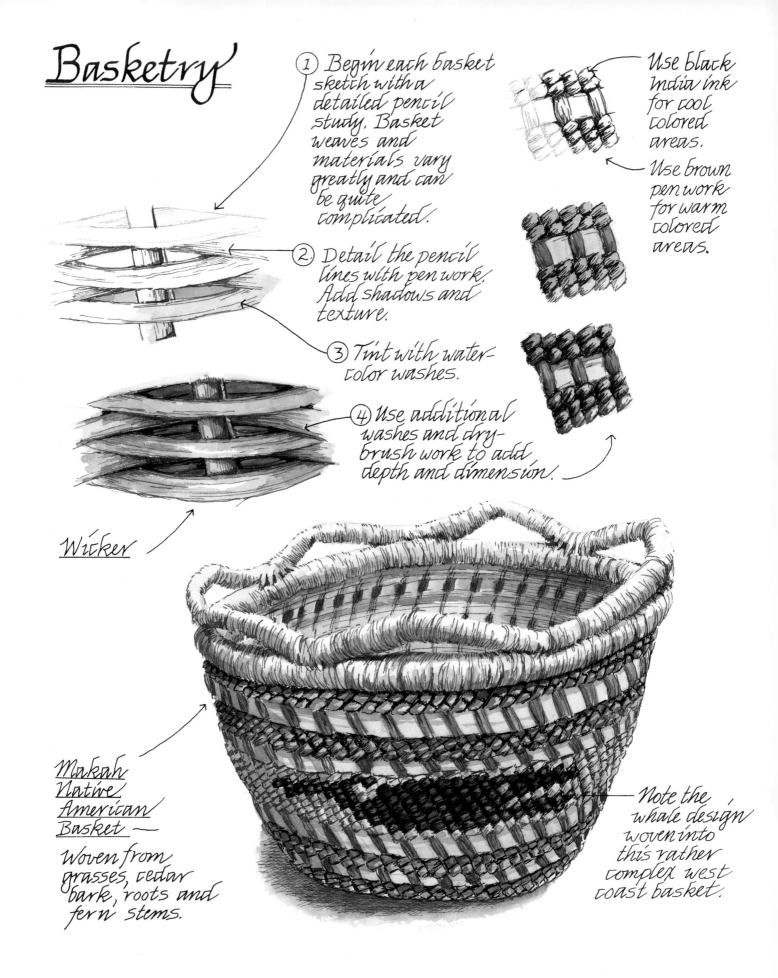

1. Begin each basket sketch with a detailed pencil study. Basket weaves and materials vary greatly and can be quite complicated.

2. Detail the pencil lines with pen work. Add shadows and texture.

3. Tint with water-color washes.

4. Use additional washes and dry-brush work to add depth and dimension.

Use black India ink for cool colored areas.

Use brown pen work for warm colored areas.

Wicker

Makah Native American Basket ~

Woven from grasses, cedar bark, roots and fern stems.

Note the whale design woven into this rather complex west coast basket.

① Design was penciled in and darkened using pen and ink. (3x0 & 1.)

② Bowl was tinted with varied washes of Burnt Umber, Burnt Sienna and Yellow Ochre.

Contour lines

Pottery

Semi-matte finishes have a low range of value contrasts, with soft, blended transitions from light to dark.

Hopi Clay Pot

③ Shadows deepened with Burnt Umber.

Bright glass trade beads provide a nice contrast to the earth tones of clay pottery.

Note: Paint high gloss pottery finishes in a manner similar to polished metal — (strong highlights and reflected color.)

125

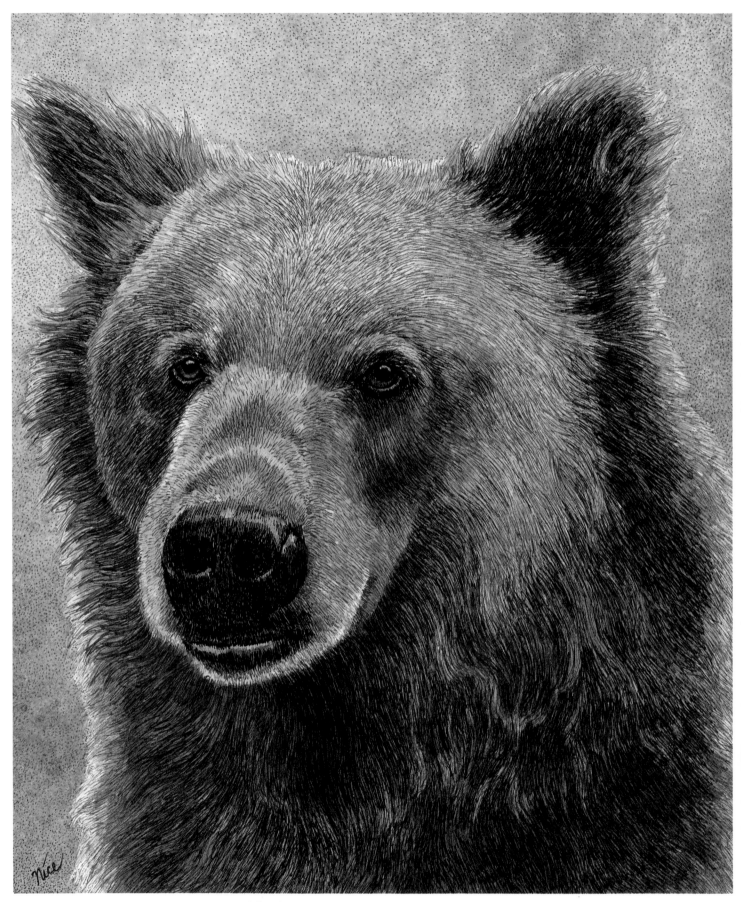

BROWN BEAR, 8½" × 7", Pen and ink, pen and ArtistColor, overlaid with watercolor.

FUR TO FEATHERS

Animals, with their earth-toned, highly textured coats, beg to be sketched in pen and ink. There are so many textures to depict! Hair coats can be short and velvety (stippling), soft, thick and furry (criss-cross lines), long and flaxen (wavy lines), or kinky, curly (scribble lines). The bear fur at left was stroked in with criss-cross and wavy line pen strokes.

Since texture is such an important part of creating close-up animal studies, I usually begin with pen work. Black India Ink in a small 4×0, 3×0, or 00 Rapidograph will work to lay the textural foundation of black, dark brown or brindle coats. Keep in mind that even the most raven black fur has areas of reflected "sheen." Leave some hair patterns un-inked to represent these glossy reflections. Deep shadows are almost solid pen work, but resist the temptation to simply fill it in with a large-sized nib. Pen strokes show, even when heavily worked.

For brown, tan, gray or chestnut coats, a textured base of colored pen work is very natural-looking. Mixing India Ink and several layers of liquid acrylic pen work, as seen in the bear sketch (facing page), can give the hair a look of shimmering vibrance. Start with the lightest colors (ochres and siennas) and layer on the sepias, umbers, Payne's grays and blacks as needed in the shadow or dark fur areas. Last of all, the watercolor washes are added to unify the coat.

Half the fun of sketching animal fur is the numerous spots, stripes, dapples and patterns with which nature has endowed the animals. Don't be afraid to focus on them, incorporating them into the basic design of the sketch.

Fish, insects and birds are the brightest members of the animal kingdom, quite often shimmering with iridescence.

These subjects are a natural for the bright, transparent qualities of watercolor. As colored washes are layered onto bodies, fins and wings, don't forget to consider the textures watercolors can provide. Spatter, blotting, bruising and impressed textures can add lifelike qualities and textural pizzazz. Pen work, either before or after watercolor washes, enhances the fine details.

Whether the subject is a family pet or a wild creature brought to a standstill with a photo lens, animal art has been popular throughout the ages and may prove to be a favorite of yours.

Animal Hair

The coats of straight haired animals can be depicted nicely using criss-cross pen or brush strokes and damp surface or wet on wet washes. Pay special attention to hair direction.

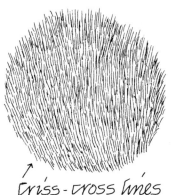

Criss-cross lines (3x0)

When stroking fur remember that each line represents a hair. Avoid hooks, tightly curled lines and cross hatching. Do not work across in rows.

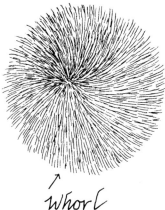

Whorl

Ridge of opposing hair.

India ink and Brown liquid acrylic pen lines.

India ink lines tinted with watercolor washes.

Wet on wet wash detailed with liner strokes (drybrush) and brown pen lines.

Combination of wet on wet washes, drybrushing and India ink criss-cross lines.

Damp surface wash (Burnt Umber)

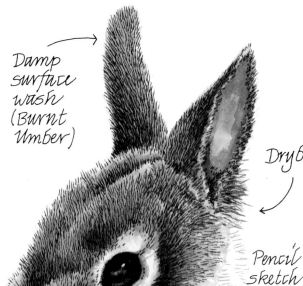

Drybrush

Pencil sketch showing hair direction.

Criss-cross India ink pen lines

Liner brush

Flat brush

128

Preliminary pencil sketch showing hair direction and value changes.

The spotted and striped coats of the animals on this page were depicted in pen and ink – (3x0 nib size). Then they were tinted with watercolor and the final touches were stroked on with a no. 4 round detail brush, using drybrush techniques.

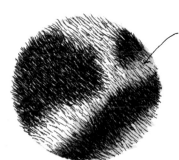

Spots and stripes –

(Where dark and light hairs meet there is a transition zone of mixed values).

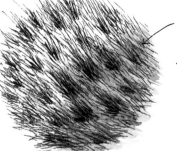

Speckled fur ~

(Flecks of dark hair mingled with light).

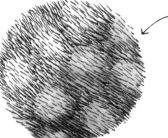

Dapples –

(Patches of hair color that vary slightly in value)

India ink

Brown pen work

129

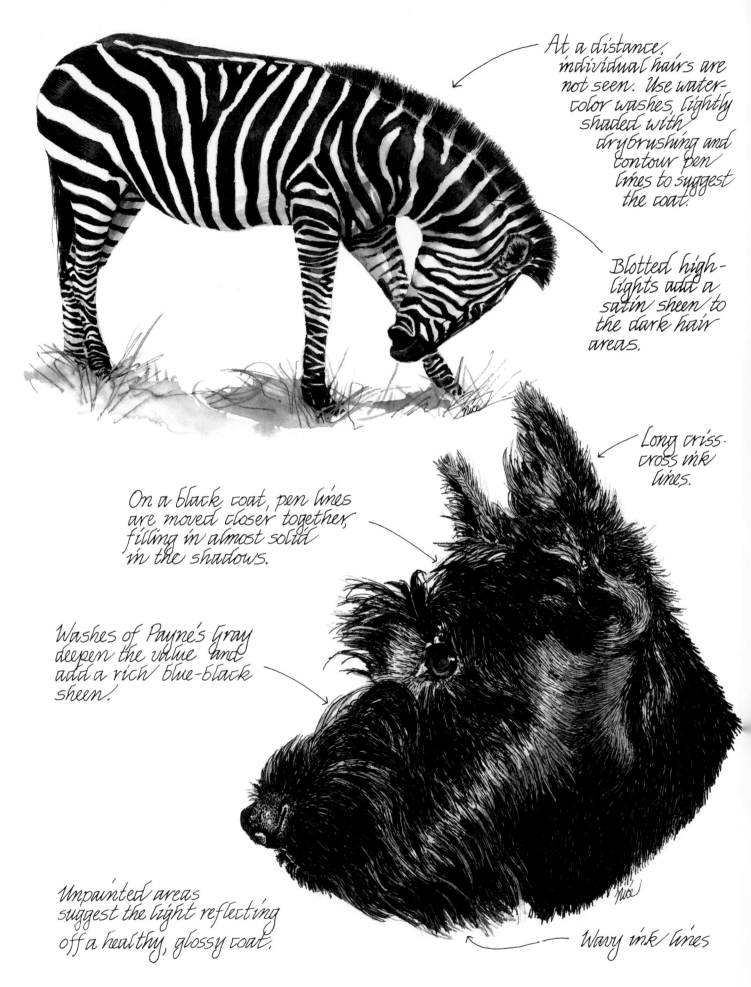

At a distance, individual hairs are not seen. Use watercolor washes, lightly shaded with drybrushing and contour pen lines to suggest the coat.

Blotted highlights add a satin sheen to the dark hair areas.

Long criss-cross ink lines.

On a black coat, pen lines are moved closer together, filling in almost solid in the shadows.

Washes of Payne's Gray deepen the value and add a rich blue-black sheen.

Unpainted areas suggest the light reflecting off a healthy, glossy coat.

Wavy ink lines

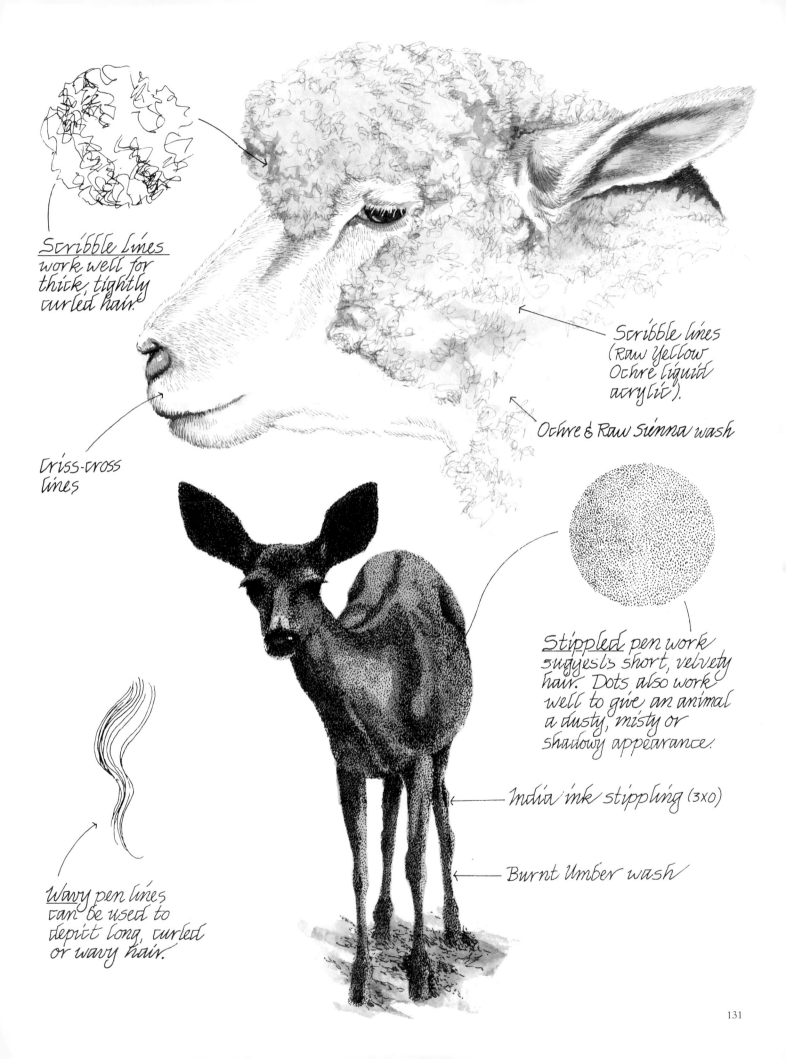

Scribble lines work well for thick, tightly curled hair.

Criss-cross lines

Scribble lines (Raw Yellow Ochre liquid acrylic).

Ochre & Raw Sienna wash

Stippled pen work suggests short, velvety hair. Dots also work well to give an animal a dusty, misty or shadowy appearance.

India ink stippling (3x0)

Burnt Umber wash

Wavy pen lines can be used to depict long, curled or wavy hair.

Scaly Skin

Fish scales form a repetitive pattern that can be suggested simply by blotting a wet wash with a paper towel, or may be mapped out in pencil and detailed with drybrush and pen work.

Ink spots & spatter

Young Trout

Patterned by blotting with a textured paper towel.

Mapped out in pencil. →

Layered washes, detailed with pen work—(Payne's Gray).

Highlights protected with liquid frisket.

Brown pen work, tinted with watercolor washes.

Goldfish

Lizard scales are plate-like, sometimes being raised like beads.

This Iguana was laid out in pencil, detailed with pen and ink, then tinted with watercolor washes

Tedious, but very effective.

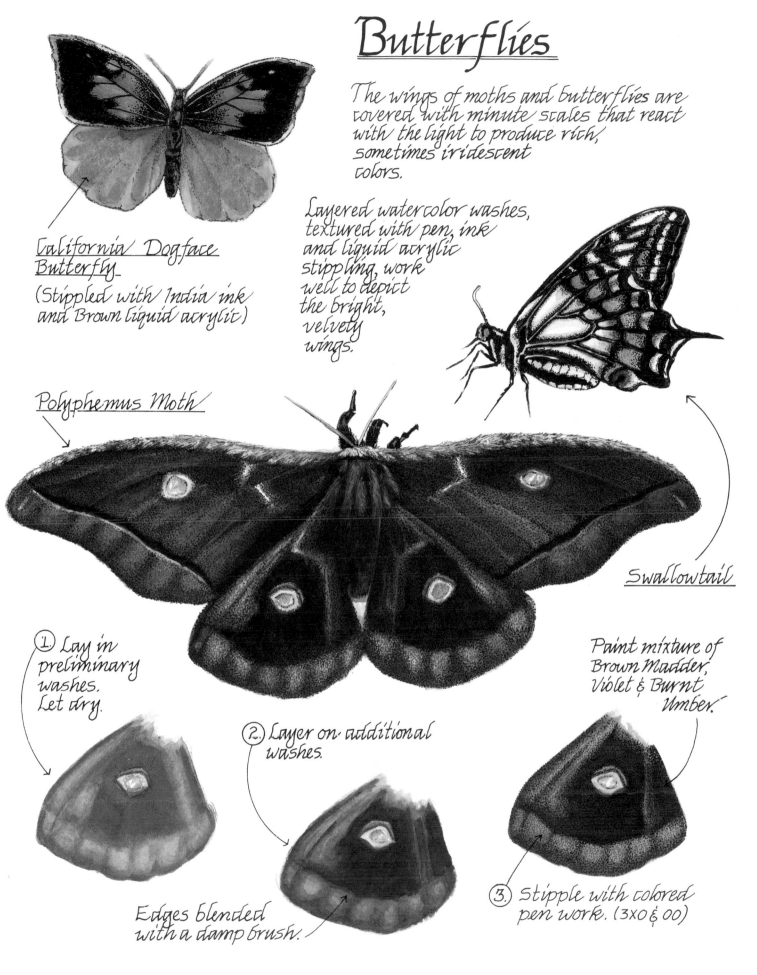

Butterflies

The wings of moths and butterflies are covered with minute scales that react with the light to produce rich, sometimes iridescent colors.

Layered watercolor washes, textured with pen, ink and liquid acrylic stippling, work well to depict the bright, velvety wings.

California Dogface Butterfly
(Stippled with India ink and Brown liquid acrylic)

Polyphemus Moth

Swallowtail

1. Lay in preliminary washes. Let dry.

2. Layer on additional washes.

Edges blended with a damp brush.

Paint mixture of Brown Madder, Violet & Burnt Umber.

3. Stipple with colored pen work. (3x0 & 00)

Blotted highlight

India ink pen work tinted with watercolor washes.

Barbs (Wavy pen lines)

Brown pen work

Parrot wing feather

Feathers

To give the flight feathers of the wing and tail the strength to push against the air, their barbs are fastened together like Velcro. Seen in detail, the curved barbs can be sketched using wavy pen lines.

Bruising

Hawk Tail feather

Damp surface spatter

The soft contour feathers of the head, back and breast have barbs that separate.

Flicker wing feather

Flight feathers seen at a distance or in motion will be less detailed. Suggest the shape of a few of the barbs with pen lines, drybrush or bruised lines.

On the body, contour feathers overlap with a hair like appearance. Use criss cross pen lines to texture them.

Bluebird

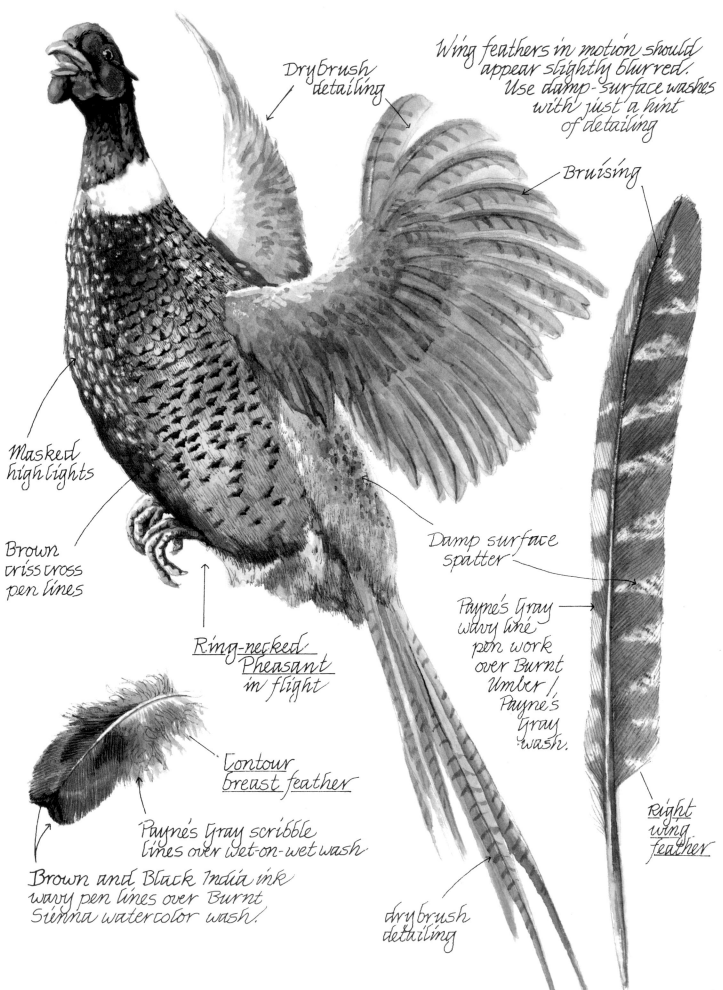

Drybrush
detailing

Wing feathers in motion should
appear slightly blurred.
Use damp-surface washes
with just a hint
of detailing

Bruising

Masked
highlights

Brown
crisscross
pen lines

Ring-necked
Pheasant
in flight

Damp surface
spatter

Payne's Gray
wavy line
pen work
over Burnt
Umber /
Payne's
Gray
wash.

Contour
breast feather

Right
wing
feather

Payne's Gray scribble
lines over wet-on-wet wash

Brown and Black India ink
wavy pen lines over Burnt
Sienna watercolor wash.

drybrush
detailing

INDEX